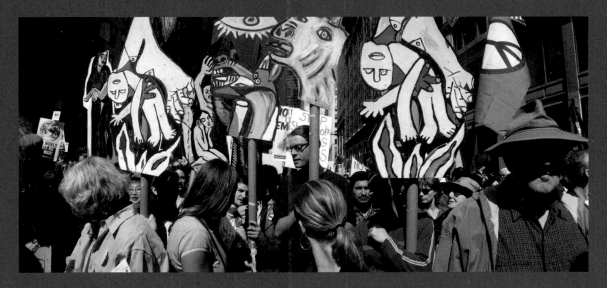

On the streets of New York (USA)

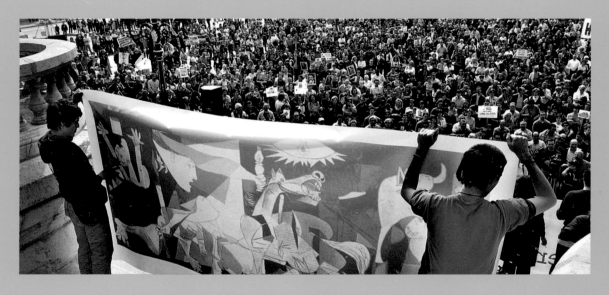

On the streets of Bilbao (Basque Country, Spain)

And Picasso Painted Guernica

Written and designed by Alain Serres

Translated by Rosalind Price

ALLEN&UNWIN

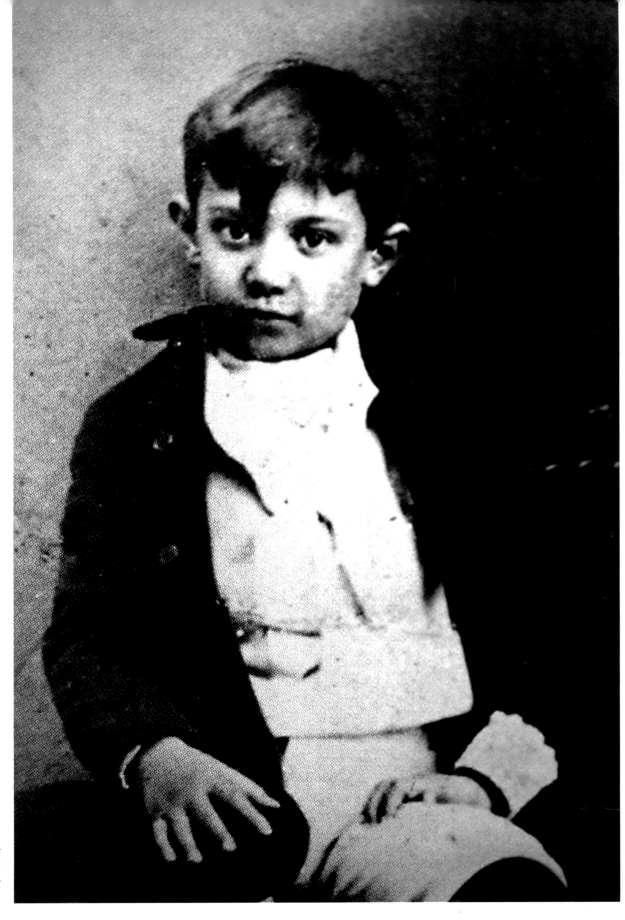

Pablo, aged 7. Even at this young age he shows a keen interest in drawing and pictures.

Edison's light

Paris, October 1881: in front of a crowd of thousands, Thomas Edison demonstrates his new invention – an electric light. Little by little, night will get brighter on Earth.

It won't be long before a train – the Orient Express – crosses Europe as far as Constantinople, gateway to Asia. And soon after, the first car will travel faster than a horse at full gallop. Little by little, the distance between countries is shrinking.

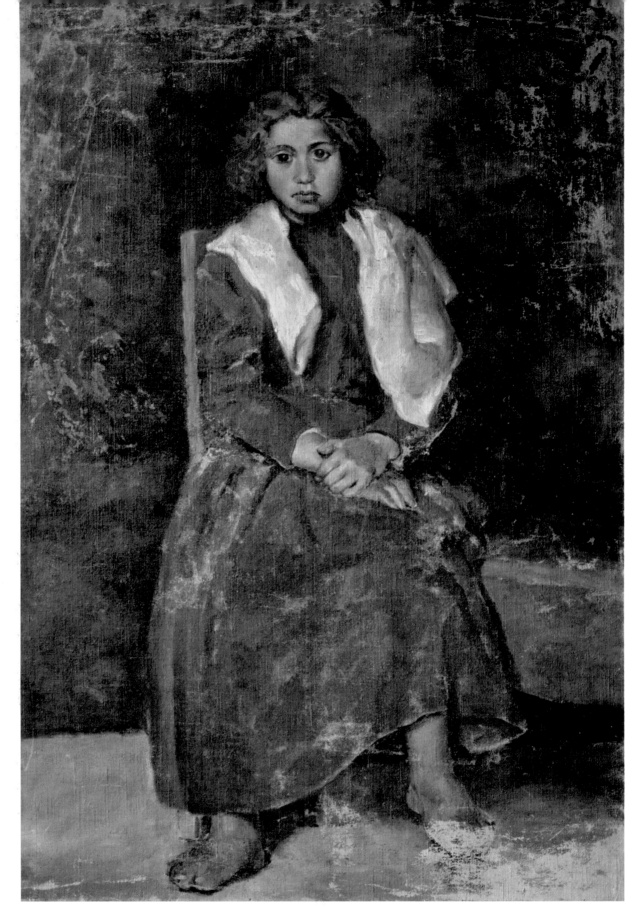

One of Pablo's first paintings, done when he was 13.

THE GIRL WITH BARE FEET, JULY 1895

In Spain, it's the end of summer. The sun is less fierce, and the oranges in Andalusia are ripe at last, plump and sweet.
On 25 October, between the sea and the olive-treed hills of Malaga, a child is born. His parents call him Pablo.

From an early age, Pablo draws and paints. He astonishes everyone. His father helps him; he's a painter and teacher at the school of Fine Arts.
Pablo's father says that a drawing should be an exact representation of the model: red fabric should look like red fabric, sadness should look like sadness.

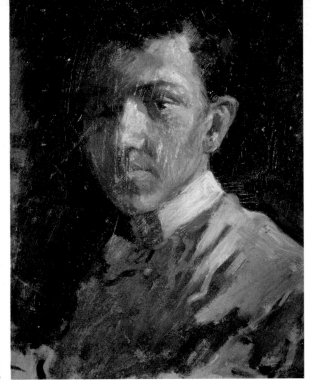

Pablo paints his own portrait for the first time, aged 14.

SELF-PORTRAIT, 1896

Pablo Ruiz Picasso is a child who devours the world with his big dark eyes, and enjoys depicting it in colour in his first sketchbooks and early paintings.
His father teaches him to look more closely at faces, birds, light, and Pablo reproduces everything perfectly. He helps his father paint doves. His father is so impressed by the boy's skill that he decides to stop painting when Pablo is 13. In his Barcelona studio, he presents his son with his paintbrushes, his paints and his very last palette.

Young Pablo takes these touching gifts and uses them to paint exactly as he wants. Within a few years, he breaks away from the lifeless pictures he has been forced to paint, and gives his brushes a new freedom. From now on, white fabric can become a cloud of feathers on snow; sky can be the canvas for a painter's dreams.

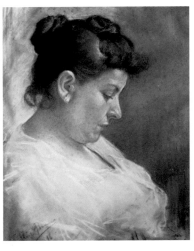

MARIA PICASSO LOPEZ, THE ARTIST'S MOTHER, 1896

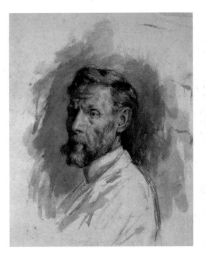

THE ARTIST'S FATHER, 1896

His father, José Ruiz Blasco, and his mother, Maria, painted by Pablo Picasso at the age of 14.

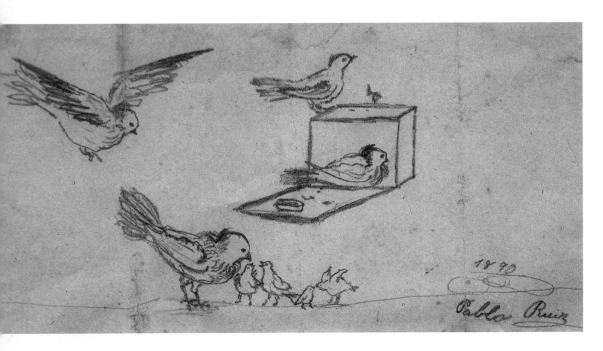

The first doves Pablo painted. He was 8 years old.

It's 1900, the start of a new century. A train snakes beneath the earth – the first underground railway, in the heart of Paris.

Ferdinand von Zeppelin flies an airship over Lake Constance, Switzerland.

And this talented young boy from Malaga turns 19. He decides to become the painter Pablo Picasso.

CHILD WITH PIGEON, 1901

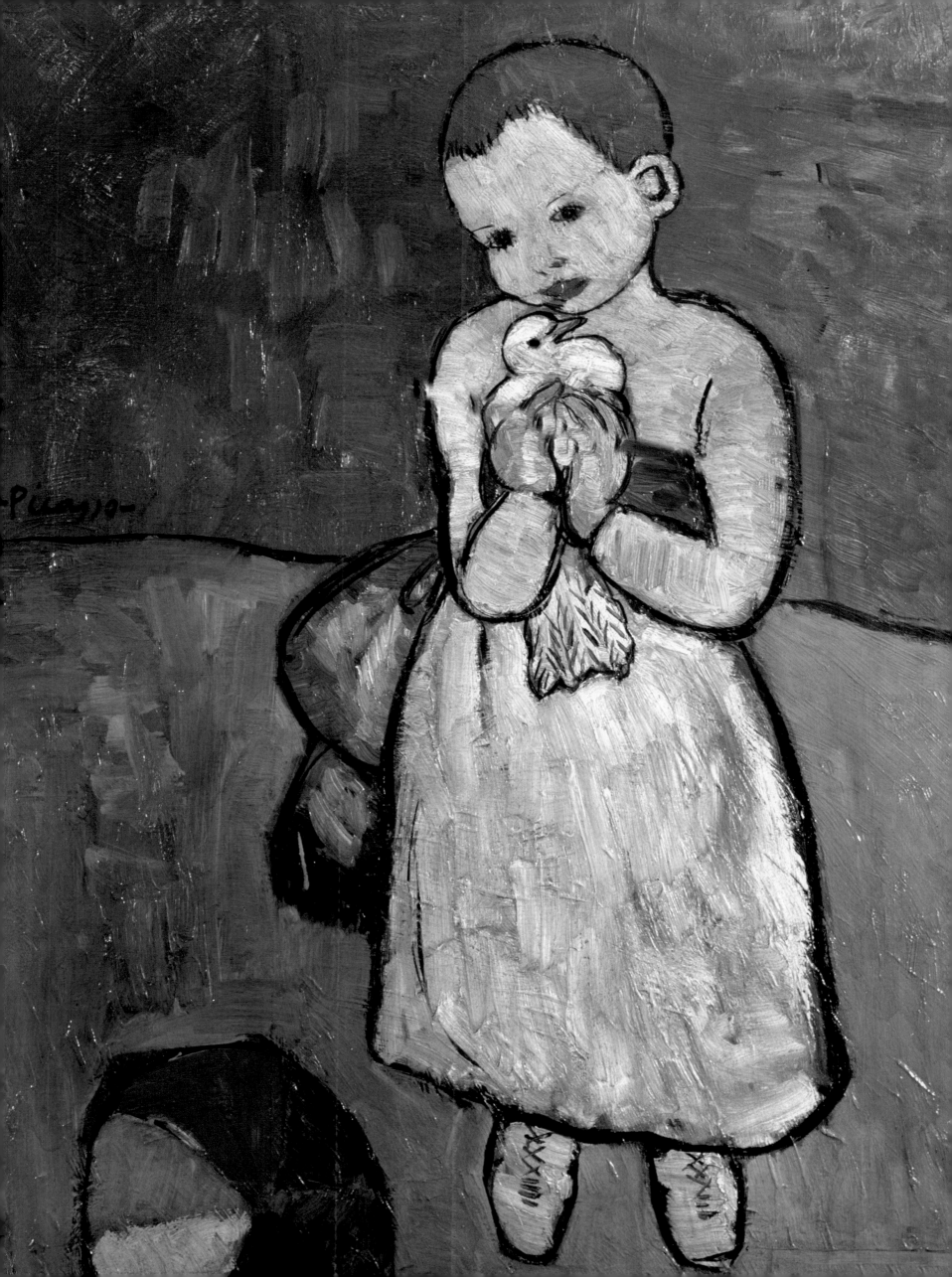

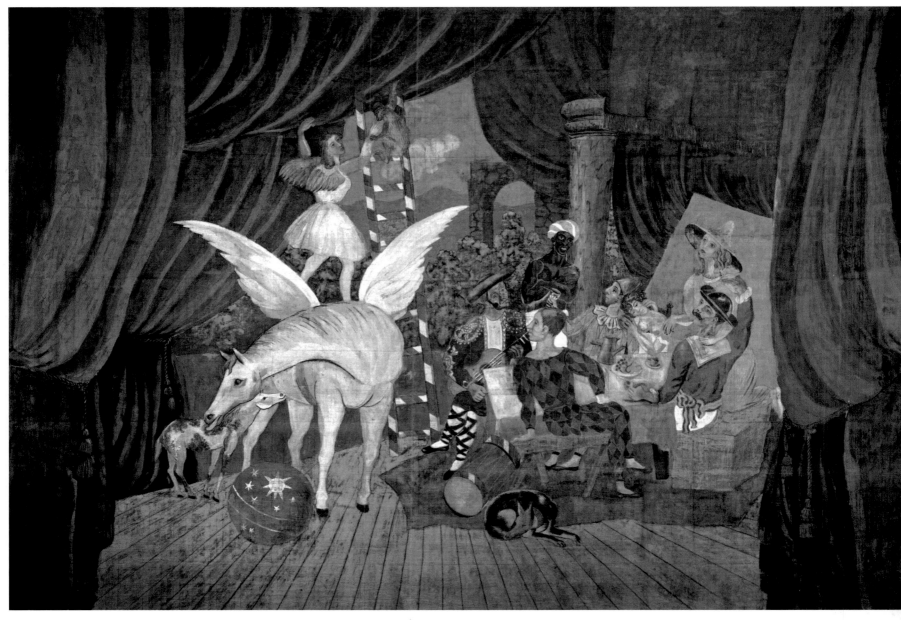

BACKDROP FOR A SCENE FROM PARADE, 1917

And harlequins who dance,
defying the laws of nature, dressed
only in a delicate sheath of satin.

Together, they make up the great
family of artists. For artists,
anything is possible.

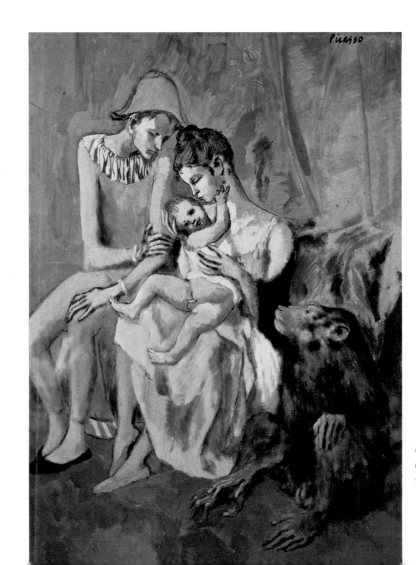

*FAMILY
OF ACROBATS,*
1905

Anything is possible.
Even being poor.
Even being blue.
Even living
side-by-side,
gazing in different
directions.
Even showing
both the left-
and right-hand
sides of a face in
a single image.

1901–1906: the phases of
Picasso's work known as
'The Blue Period' and
'The Rose Period' follow one
another. At first Picasso's
paintings are dominated by
cool tones, conveying
melancholy and misery,
then the colours
warm up, restoring hope.

ACROBAT AND YOUNG HARLEQUIN,
1905

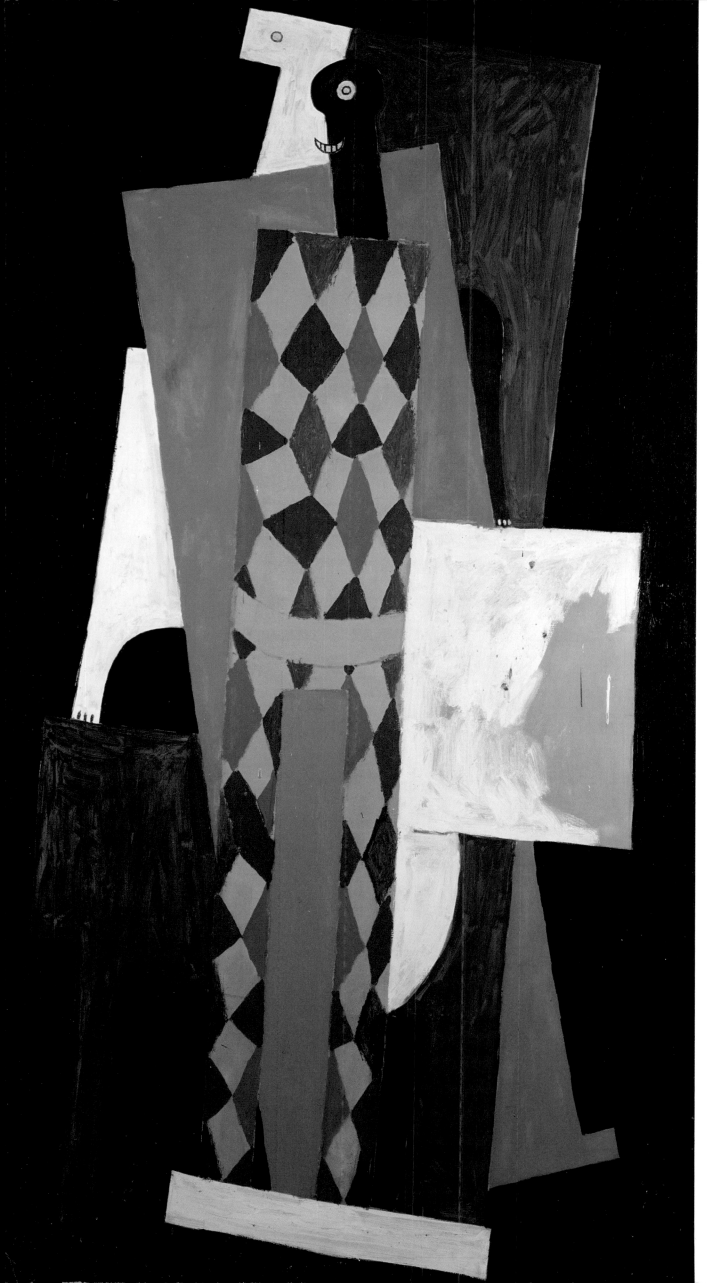

What if one could see everything through a blaze of emotion that seems more real than external reality? Picasso invents a way of seeing that nobody has ever dared think of before. It's as if his eye magically sees the world through 'cubist' lenses!

Picasso and a fellow painter, George Braque, developed a style that was given the name 'Cubism'. They painted people and objects from many different viewpoints, as if they could see every surface at the same time. Using geometric shapes, sharp angles and overlapping areas, they experimented with pictures that looked flat, rather than giving the illusion of perspective. Picasso's first painting of his 'Cubist Period' was *Les demoiselles d' Avignon* in 1907.

HARLEQUIN,
1915

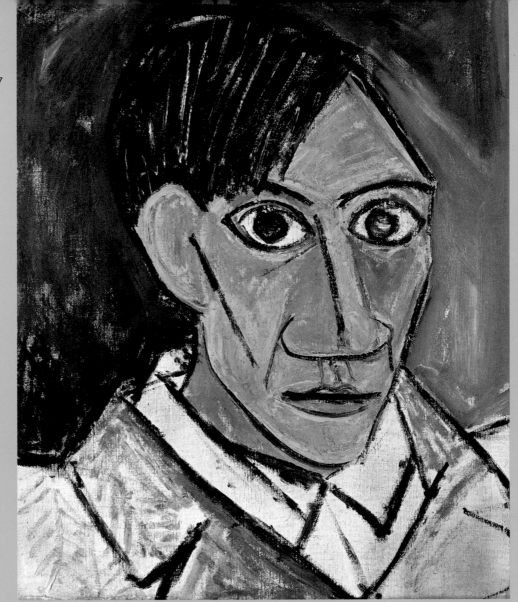

Self-Portrait, 1907

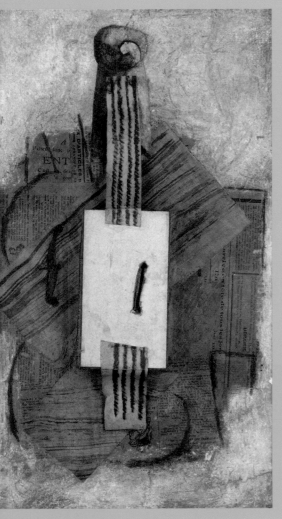

Violin, 1913–1914

Paris bubbles with ideas. Writers challenge the official language prescribed by the French Academy; artists subvert the rules of art. The Dadaists are completely dada, and the Surrealists are far from realistic! They all dream of absolute freedom – freedom that can transform everything ugly in the world: for 8 million people have just been killed in World War I.

Picasso whips up these winds of change. He creates collages. He introduces bits of newspaper articles into his pictures. He even allows himself the freedom to go back to his father's more precise, naturalistic style of working . . .

His paintings travel to Switzerland, to the USA, to Spain. Young painters everywhere are inspired by his work.

In 1921, two years after the end of the horrifying war, his first son, Paul, is born. Pablo paints little Paul peacefully painting.

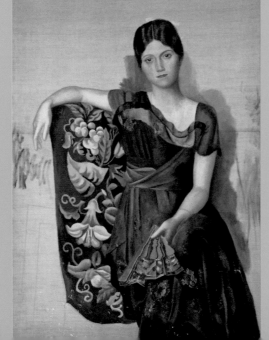

Paul's mother, Olga. One of the pictures from Picasso's 'Classical Period'.

Portrait of Olga in a Chair, 1917

Paul drawing, 1923

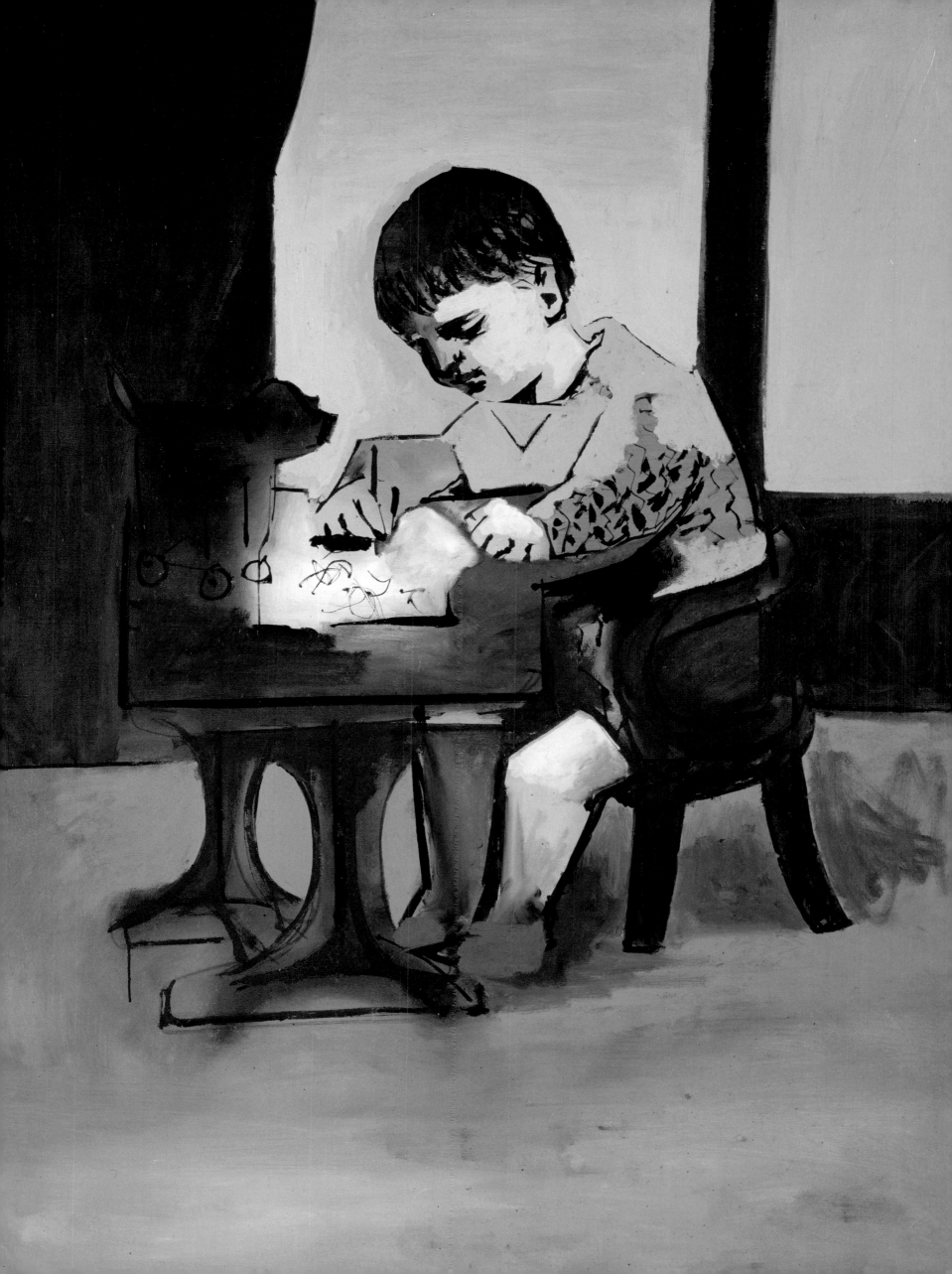

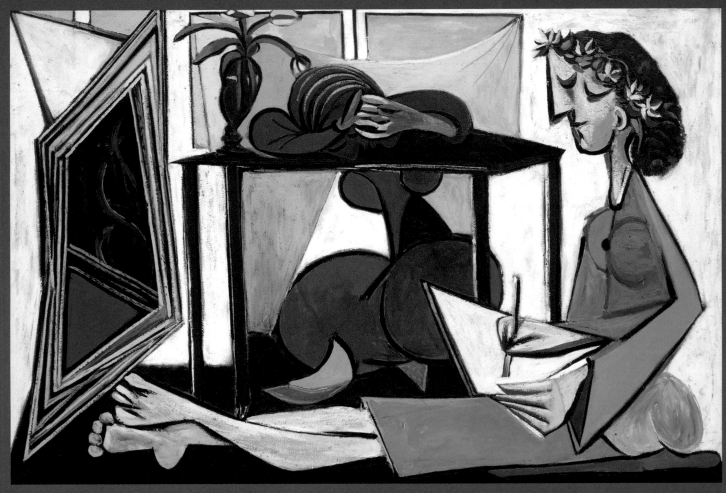

Picasso paints all the time. He paints anything and everything:
love, Spain, the gentleness of women, people reading and painting,
his son, and his daughter Maya who is only nine months old when,
in the summer of 1936, his own country of Spain
is suddenly at war . . .

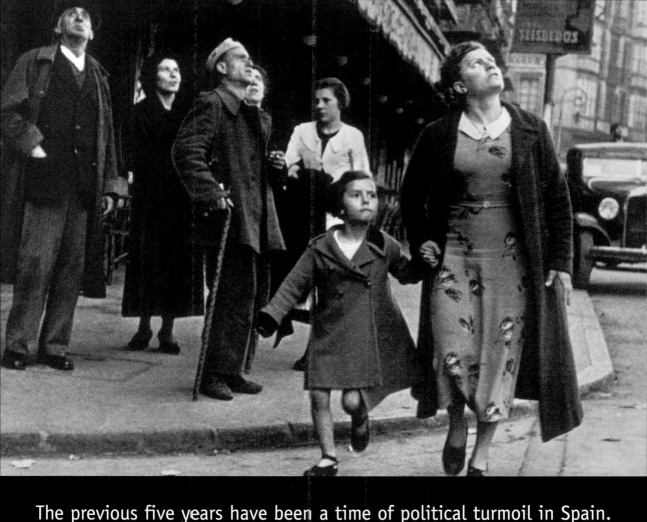

The previous five years have been a time of political turmoil in Spain. Left-wing parties won most votes at the elections and set up a Spanish Republic to replace the old monarchy. But some groups did not accept this new form of government. When the Republicans win again at the 1936 elections, General Franco and a section of the Spanish army decide to take military action against the Republic. On 18 July 1936, they launch a coup d'etat, starting three long years of bloody civil war.

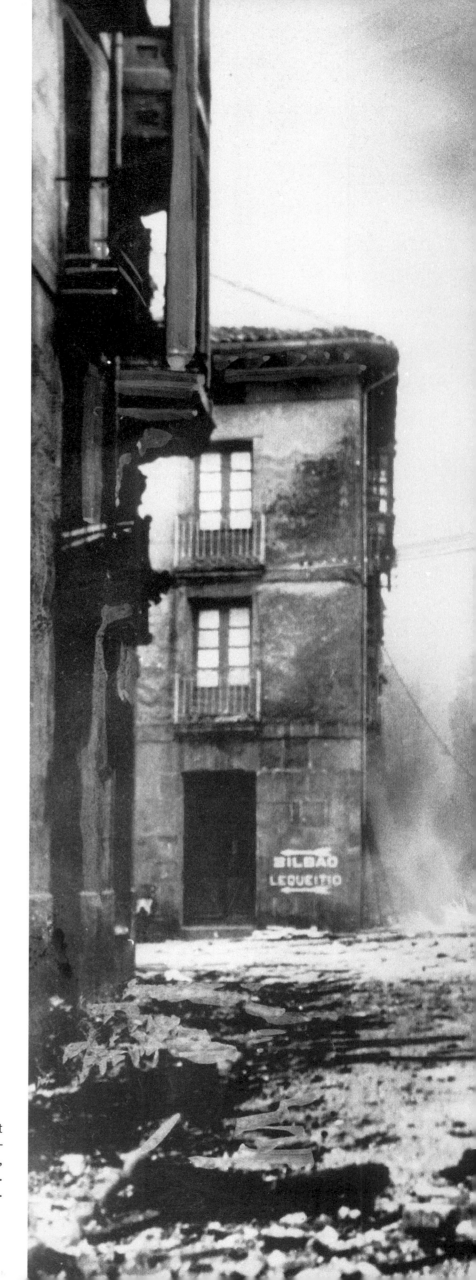

On Monday 26 April 1937, at 4.30 p.m.,
above the small Basque town of Guernica
in the north of Spain, the sky darkens.
Town bells begin to ring ominously.
Fifteen minutes later, the first planes
unleash their bombs over the squares
and streets and houses. They are German
bombers of the Condor Legion,
followed by Italian planes.

It's market day in Guernica. People have
come from neighbouring villages to buy
and sell poultry, vegetables, cattle. At the
sound of the first plane, a young bull
goes mad and rampages in all directions.
People panic and race for shelter in the
houses. Bombs rain down. Roofs collapse.
Fires leap from building to building.

France and Great Britain refuse to help the Spanish Republic, but
two dictatorships – Mussolini's Italy and Hitler's Nazi Germany –
give military support to General Franco. In many countries,
volunteers rally to go and fight alongside the Spanish Republicans.
They form the International Brigades.

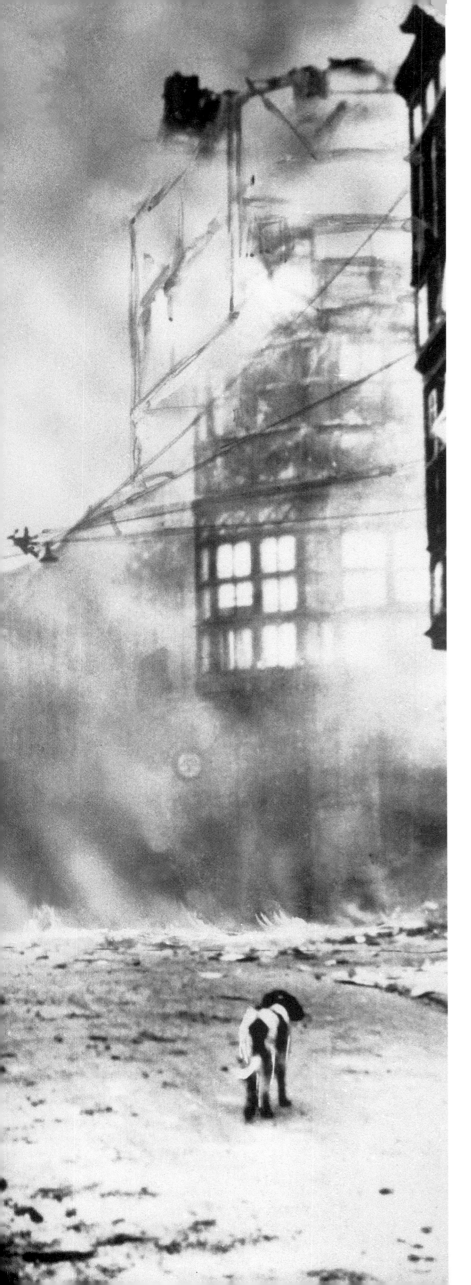

This photo, taken under difficult conditions, was touched up at the time to give a more realistic impression.

Every five minutes, another bomber flies low over the town. Families flee into nearby woods; they are gunned down from the planes. It's 3 hours and 15 minutes of horror: 50 tonnes of bombs, 3000 firebombs.

The small town of Guernica contains an important building, the Casa de Juntas, that houses the history and laws of the Basque people – it's their store of memories. In the courtyard of this symbolic building grows an oak. For centuries, this particular tree has united Basques from all the provinces: the Guernica tree, *Guernikako arbola*.

At 7.45 p.m. the last plane disappears. Fires rage; the town is almost burnt to the ground. The church is still standing. The house of the Basques and the special tree are still standing. But where are the men and women, and their children?

The Spanish Civil War claimed 400 000 victims and heralded World War II.

Several hundred inhabitants of Guernica and its surroundings are killed or wounded. Three-quarters of the city is destroyed; the world is appalled. This aerial bombardment of Guernica is engraved in human history because it is the first attack aimed deliberately at defenceless civilians, not a military target.

On 1 May, Picasso encounters the horror on the front page of his newspaper. His eyes are drawn to a photograph as relentless as the interminable bombing it documents.

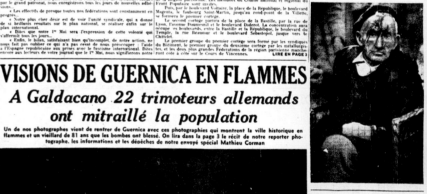

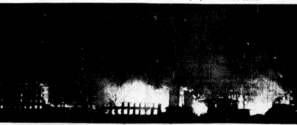

Picasso reads *Ce Soir [Tonight]* a daily paper launched only a few months earlier by his friend, the writer Louis Aragon. The first photographs of Guernica appear on 1 May.

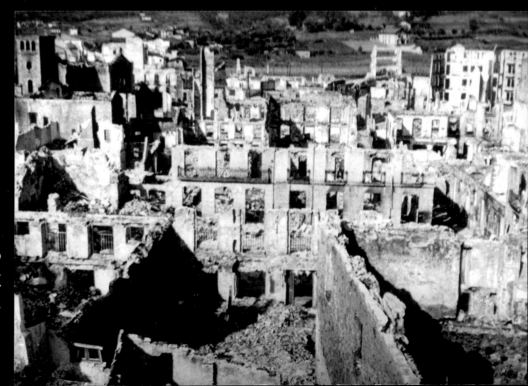

The Basque town of 6000 inhabitants is reduced to rubble. In the days before and after, other Spanish villages are also pounded.

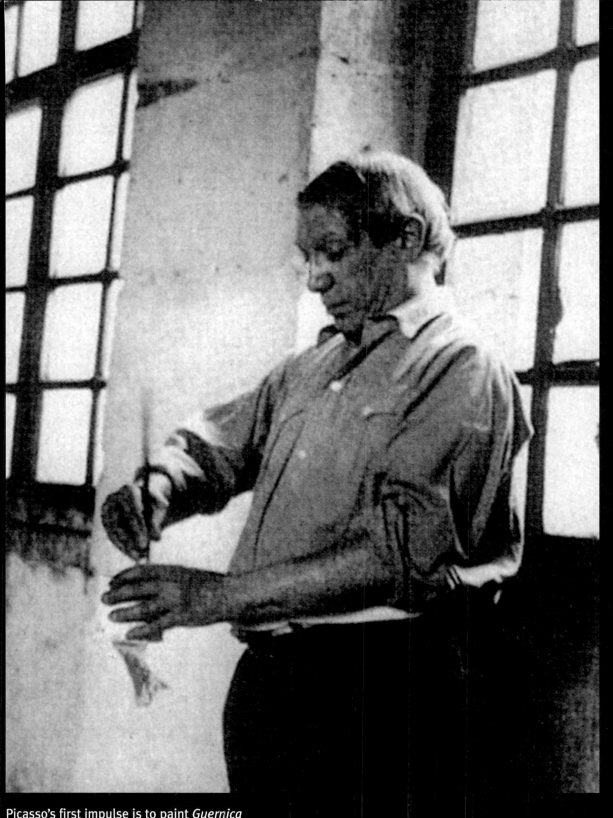

That same day, in his studio on the Rue des Grands-Augustins, Picasso begins to hurl ideas onto paper, to scrawl his anger. He begins to conceive a painting that will be as powerful as his fury.

The Spanish Republic has already commissioned a work from him, to hang side by side with works by Miró and Calder in the Paris International Exhibition, due to open in a few weeks.

Picasso's first impulse is to paint *Guernica* in black and white. He experiments in colour, but resolves to stick to his initial plan.

He has been thinking of painting his studio, but tonight he makes a decision: he will paint his grief as a Spanish artist – the painting, *Guernica*.

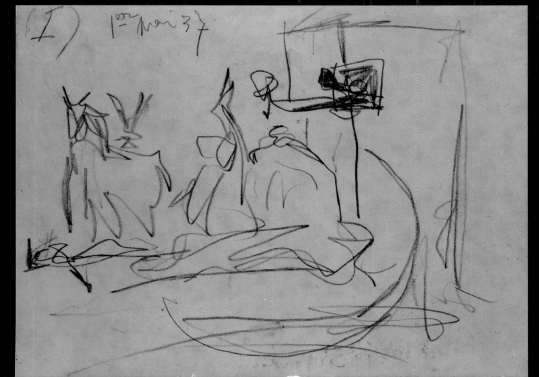

ROUGH FOR GUERNICA (I), 1 MAY, REINA SOFIA NATIONAL ART MUSEUM

The first drawing that Picasso dashed off, in response to what he'd read in the newspaper.

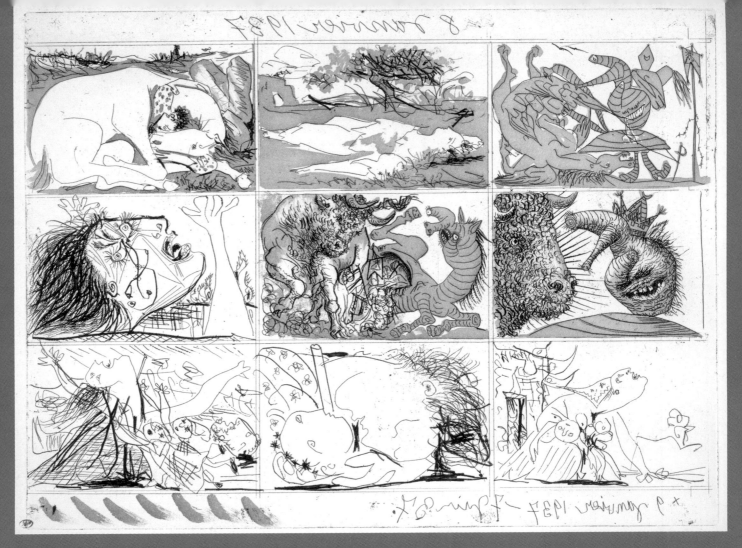

At the start of 1937, Picasso does this etching, which has to be read back-to-front, like a stamp. In a style of drawing that foreshadows the way he draws *Guernica*, he asserts his rejection of violence and fascism.

DREAMS AND LIES OF FRANCO (BOARD II, STAGE A), JANUARY 1937

Picasso draws inspiration from anti-Franco etchings he made
at the start of the year, from powerful works by the painters Goya and Rousseau,
from childhood memories of bulls and horses in his long-lost Spain,
and legends of old.

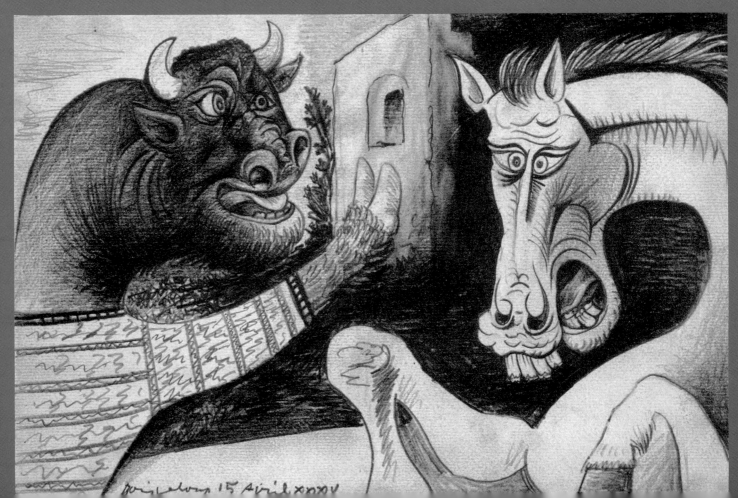

For several years, Picasso has drawn many minotaurs and horses taken from Greek mythology and the Spanish bullrings.

MINOTAUR AND HORSE, 1935

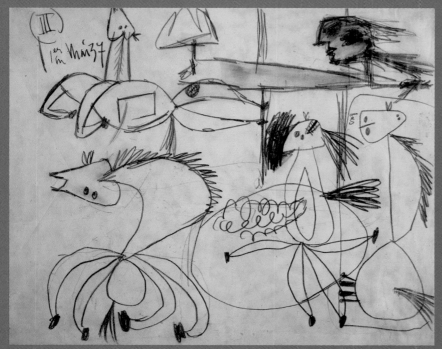

STUDY FOR GUERNICA (III), 1 MAY, REINA SOFIA NATIONAL ART MUSEUM

How can an artist communicate the torments of body and soul in black and white? Is it acceptable to evoke a massacre with a simple, childlike drawing?

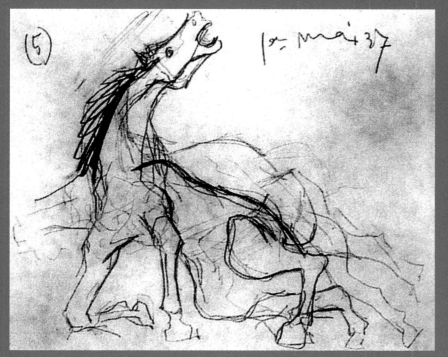

HORSE (V), 1 MAY, REINA SOFIA NATIONAL ART MUSEUM

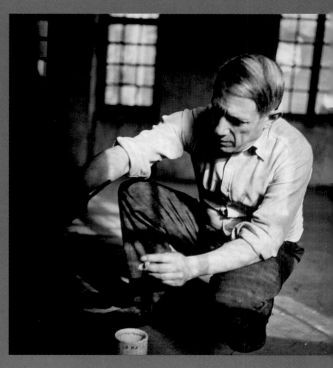

Throughout the painting of the canvas, his friend Dora Maar takes photos, leaving an invaluable record of the work's evolution.

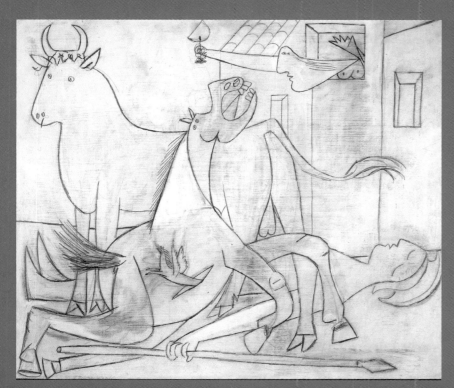

STUDY FOR GUERNICA (IV), 1 MAY, REINA SOFIA NATIONAL ART MUSEUM

How to make an image more powerful than the blast of 50 tonnes of bombs? How to make it live on, long after the dust and debris has settled? How to make it linger in the mind's eye, even when people have stopped looking?

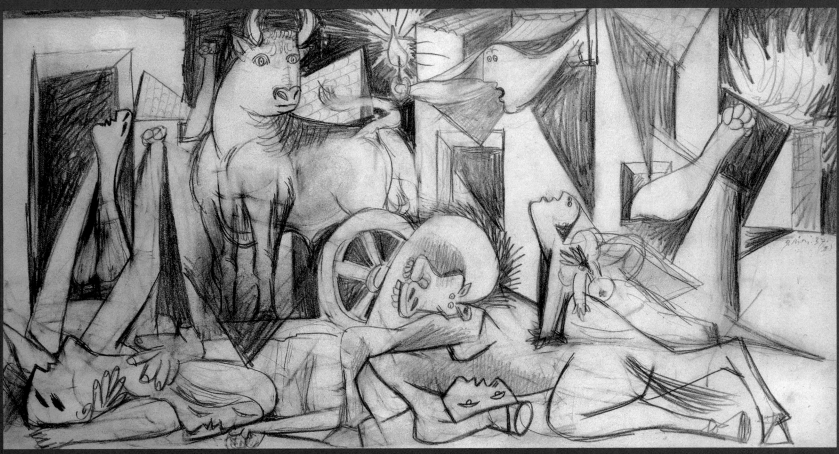

STUDY FOR GUERNICA (VII), 9 MAY, REINA SOFIA NATIONAL ART MUSEUM

On 9 May, after dozens of roughs, the concept for the huge mural begins to take shape on paper. But Picasso feels he must keep on drawing, experimenting, refining the work. Make it more powerful, more truthful. Have doubts. Discard ideas and start again.

THESE FOUR STUDIES: REINA SOFIA NATIONAL ART MUSEUM

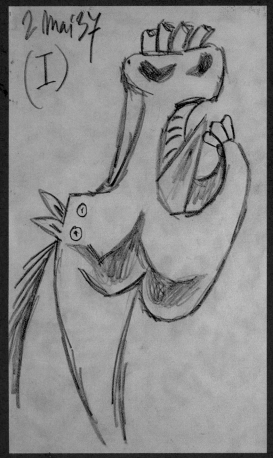

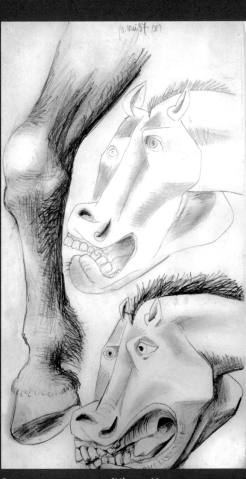

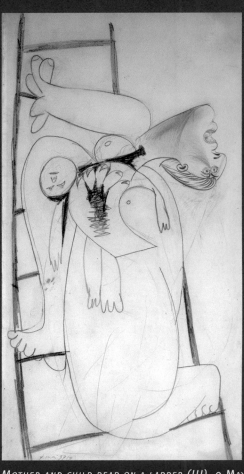

HORSE'S HEAD (I), 2 MAY

STUDY FOR THE HORSE (II), 10 MAY

MOTHER AND CHILD DEAD ON A LADDER (III), 9 MAY

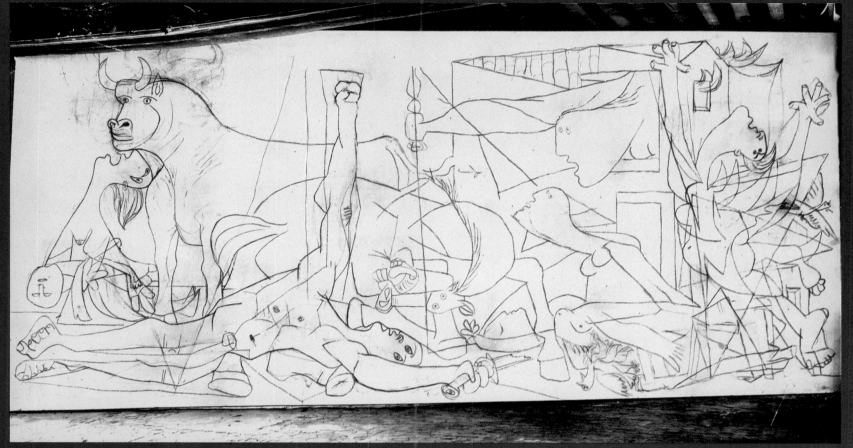

Guernica, stage I, 11 May

On 11 May, he takes delivery of more than 7 metres of canvas.
As soon as this is fixed to the wall, Picasso seizes a piece of charcoal,
climbs his stepladder and starts drawing the characters that possess him.

The first stage of the canvas, photographed by Dora Maar in Picasso's studio.

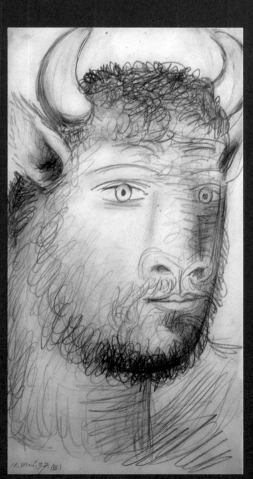

Bull's head (III), 10 May

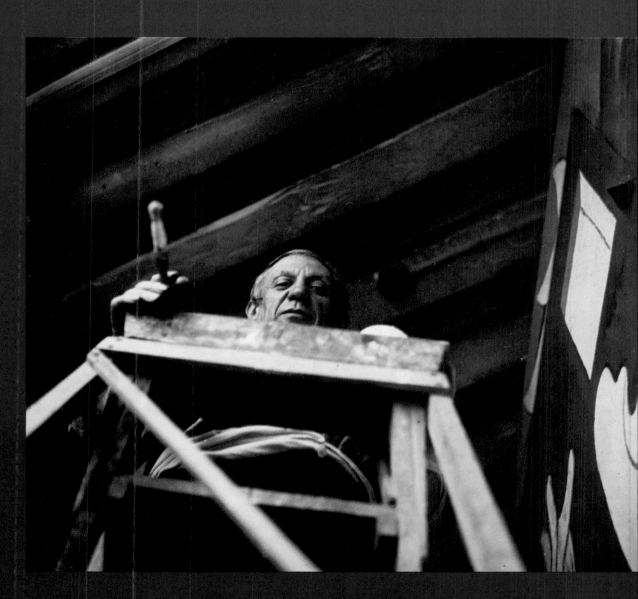

For two days and nights he scarcely sleeps.
He paints in black, white and grey, with barely
a hint of living colour. *Guernica* progresses
fast. But even as he paints, Picasso imagines
and re-imagines the work, as if the very act
of painting helps him think.

He's determined to hide nothing.

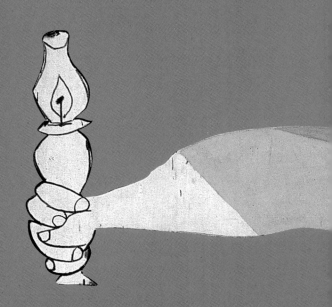

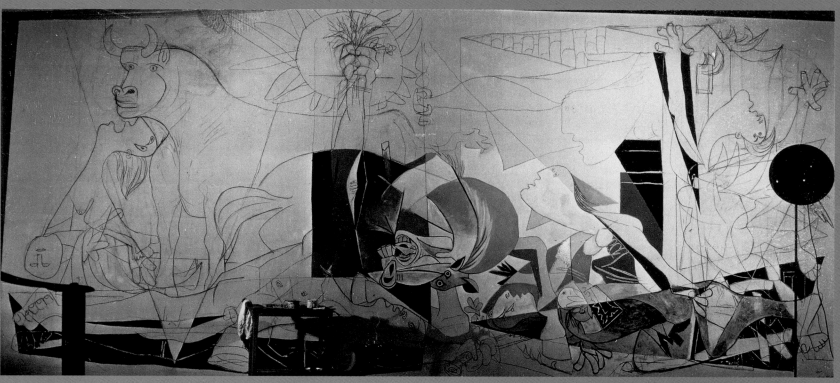

GUERNICA A, STAGE II

Right from the start, a man's arm
is in the picture. An arm with a
shattered weapon and a flower
growing from its clenched fist.
Perhaps it's from a freedom fighter,
powerless in the face of bombers—
torn apart?

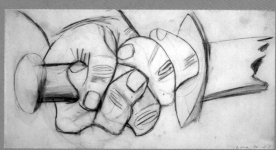

WARRIOR'S HAND WITH BROKEN SWORD (III), 13 MAY,
REINA SOFIA NATIONAL ART MUSEUM

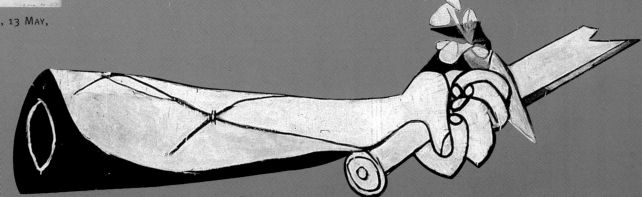

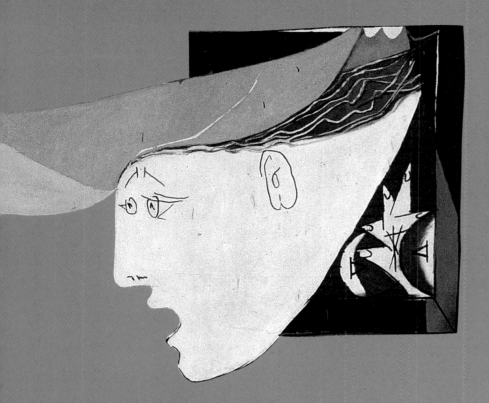

With a single stroke, Picasso draws a line almost down the middle of the picture, which remains there right to the end. It's like the central pillar holding up a house, or the sky. Way up high, he draws an oil lamp. It's carried by a woman with outstretched arm who swoops in through a window to rescue the town from darkness.

This lamp is the tip of a tragic triangle. A small flame of hope, above the horrifying pyramid of bodies?

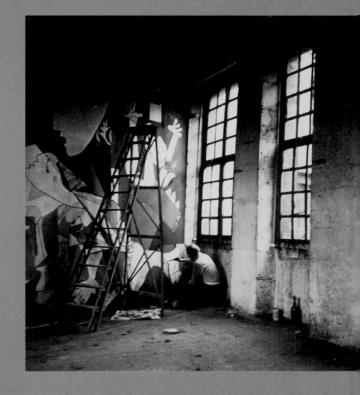

THE LAMP-CARRIER, THE MOTHER WITH CHILD, AND THE SOLDIER'S ARM WITH THE FLOWER REPRODUCED ON THIS DOUBLE PAGE ARE DETAILS FROM THE FINAL STAGE OF *GUERNICA*.

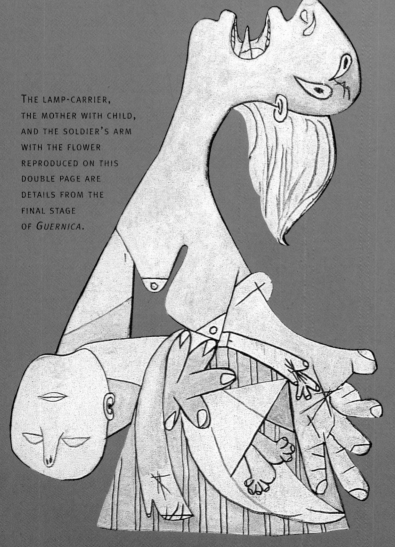

Picasso throws back the mother's head, and her child's. He shatters the familiar image of Virgin and Child. Shows the world upside-down, like the child who dies before it can live, like the rain of steel that dreadful day. Like those eyes, those nostrils, made of tears. Like the mouth of the child that makes no sound, and the mother's that cries out, that screams. Who, in the midst of all this madness, can reassure us that the child is only wounded?

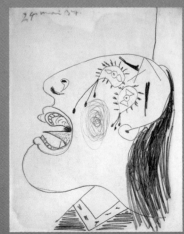

HEAD OF WOMAN WEEPING (II), 24 MAY, REINA SOFIA NATIONAL ART MUSEUM

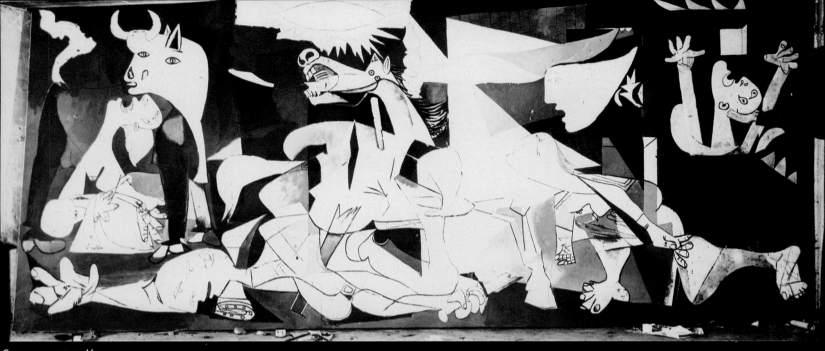

Guernica, stage V

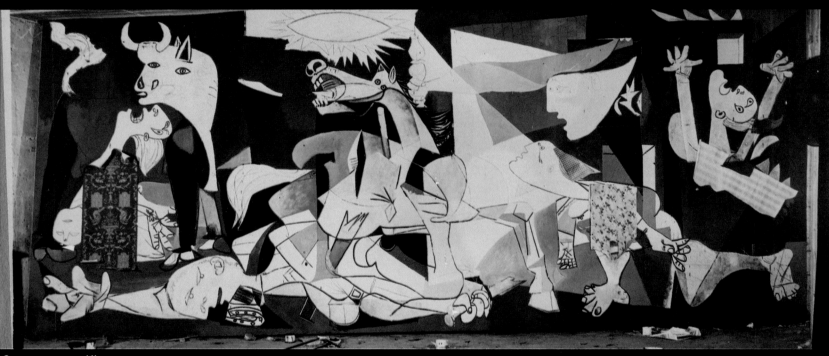

Guernica, stage VI

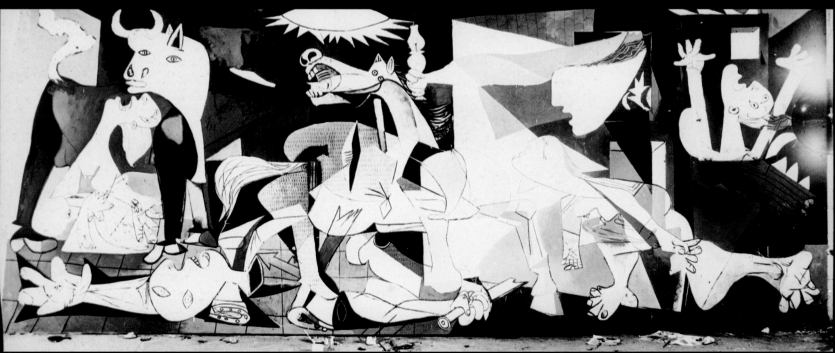

Guernica, stage VII

On 4 June, Picasso gives a finishing touch
to the painting. *Guernica* is now ready for
the eyes of the world. And the whole world
sees those animals and humans trapped
in a house that's being bombed.

There's even another house within this
house, but no one is safe.

A woman drags herself across the ground
on her knees, staring at the light. Her feet,
her hands, have the heavy weight of a bull.

Another woman seems to be falling down
a well – but not a water well, a well of fire.
There are no helping hands.
There's no one at the window.

And what's that outside, up high?
More horns? More bulls? Or maybe flames
from the burning town? How should we
interpret what we see?

For Picasso, and the painters of his century,
painting is different from photography.
It's not just telling or describing;
it's asking questions.

The crying and screaming, the clatter of hoofs
on paving, the shock of metal hitting the
ground, shattered furniture . . .
What sense can we make of this
deafening uproar? A horse whinnies,
its mighty chest swollen by the storm.

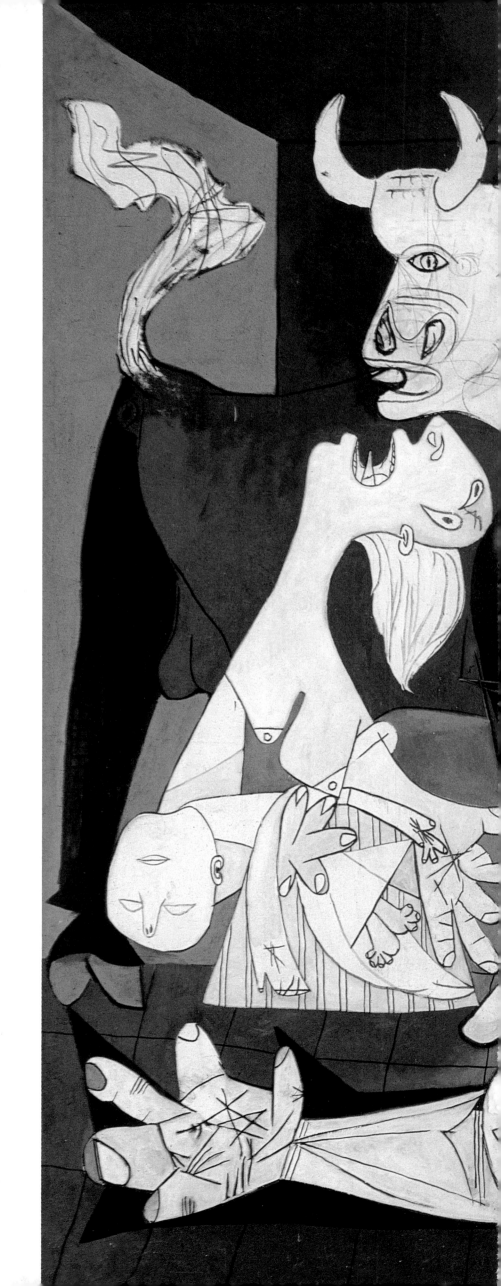

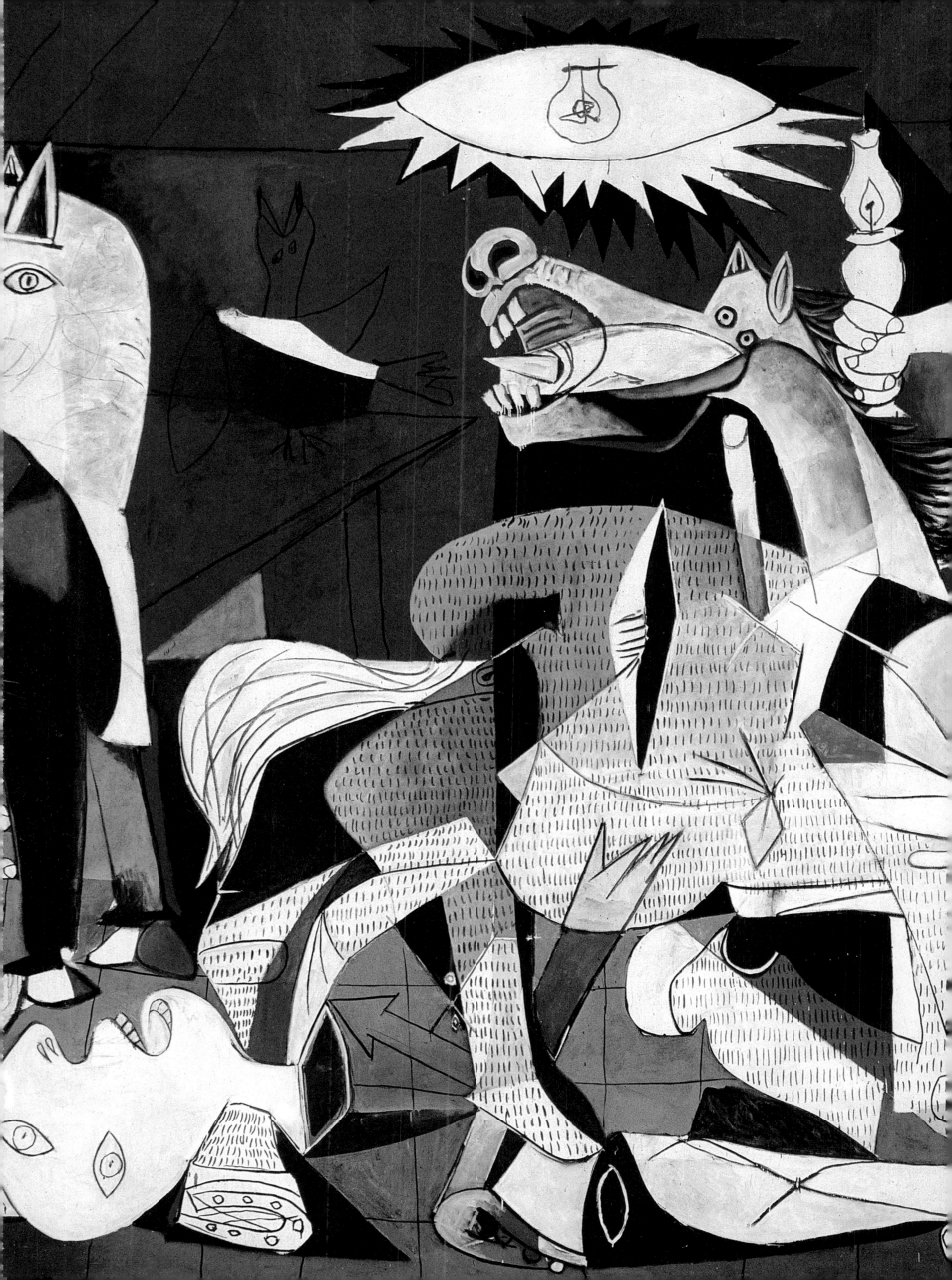

Throughout his work on the canvas, Picasso draws dozens more sketches on paper. He tests things. He even considers whether the picture could do with a great drop of red blood. He tries it out, moves it to a new position, then abandons the idea.

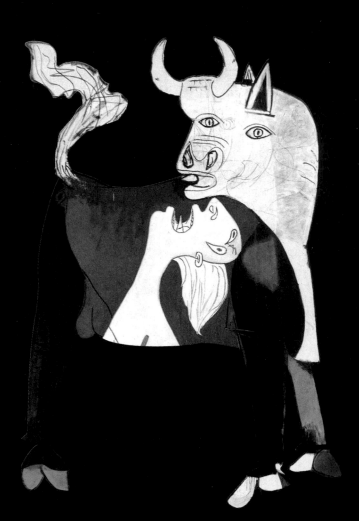

BULL, 20 MAY, REINA SOFIA NATIONAL ART MUSEUM

Who is this bull with his two human eyes staring out at us? Why is he silent? What has happened to his brute strength? Then Picasso suddenly flips the body of the beast around, but his eyes stay fixed on us.

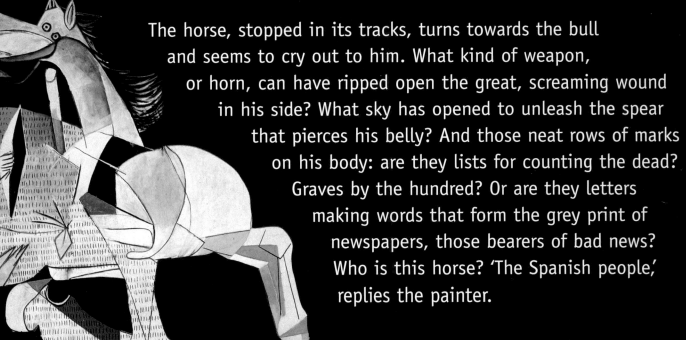

The horse, stopped in its tracks, turns towards the bull and seems to cry out to him. What kind of weapon, or horn, can have ripped open the great, screaming wound in his side? What sky has opened to unleash the spear that pierces his belly? And those neat rows of marks on his body: are they lists for counting the dead? Graves by the hundred? Or are they letters making words that form the grey print of newspapers, those bearers of bad news? Who is this horse? 'The Spanish people,' replies the painter.

THE BULL (TOP RIGHT), THE HORSE AND THE BIRD REPRODUCED ON THIS PAGE ARE DETAILS FROM THE FINAL STAGE OF *GUERNICA*.

Picasso also paints a bird, with its head thrust high. It's shouting itself hoarse. It's calling out to us from the shadows, trying to tell us something. Something important. But who can translate the wordless cry of birds?

THE EXHIBITION OPENS ITS DOORS ON 25 MAY. THE SPANISH REPUBLIC PAVILION SETS ASIDE A WHOLE WALL FOR THE HUGE PICTURE THAT PICASSO PROMISES TO DELIVER VERY SOON . . .

It's not until 1981 that *Guernica* is hung
in the Prado Museum in Madrid (Spain),
and then in the Reina Sofia National Art Museum.

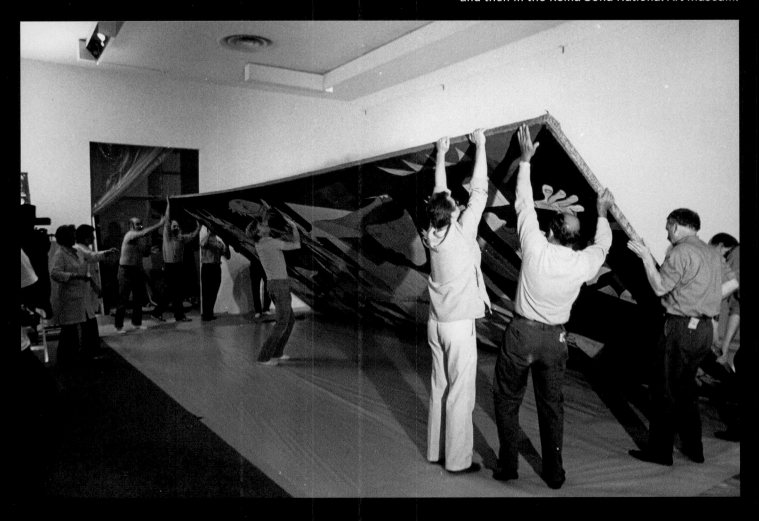

Guernica travels on board the transatlantic liner, *Normandie*,
to the Museum of Modern Art in New York, in 1939. There it stays for 42 years.
Picasso stipulates that the painting must not be hung in Spain until Franco is gone
and the country is once again free and democratic. For the same reasons,
Picasso himself never again sets foot on Spanish soil.

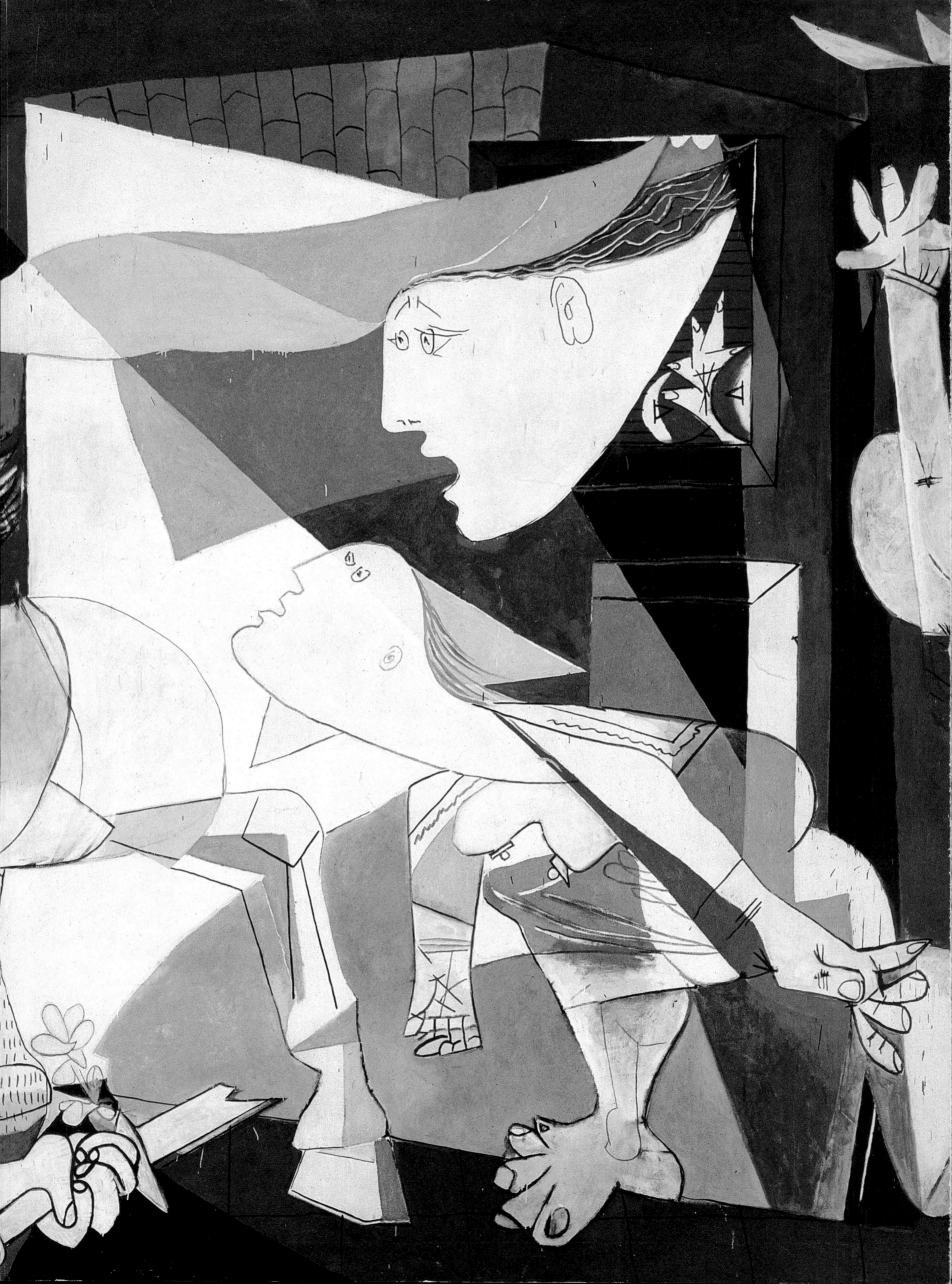

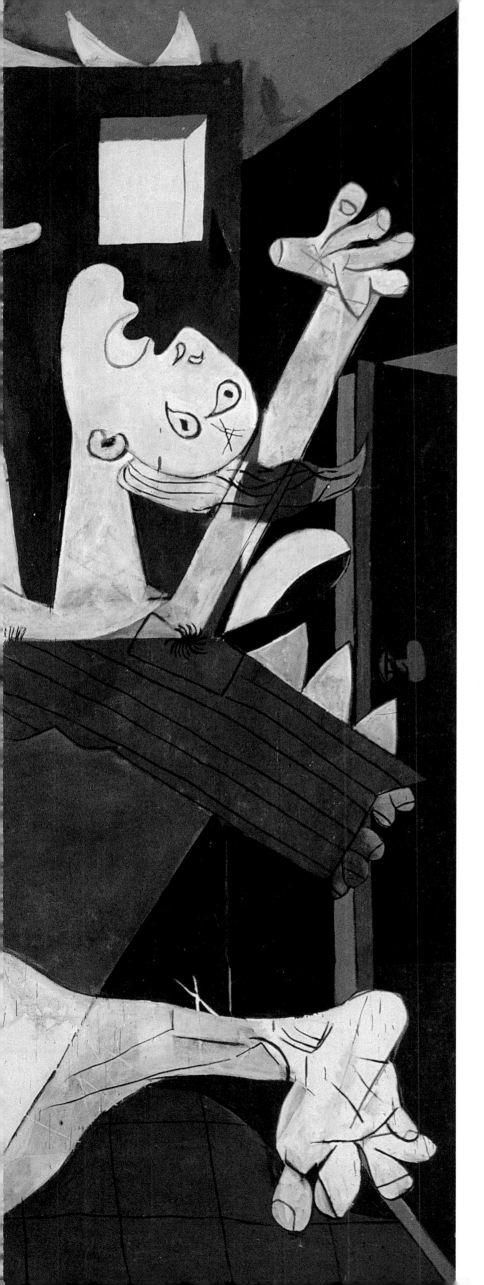

Guernica, 4 June 1937,
Reina Sofia National Art Museum.
Dimensions of the painting: 7.82 x 3.51 metres.

34

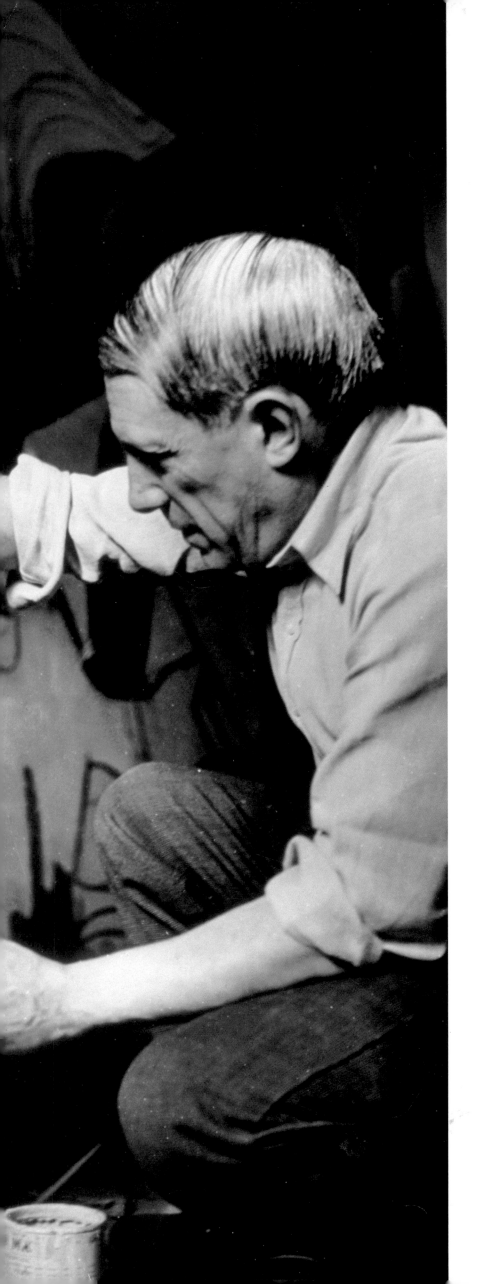

It whinnies in a way no horse has ever whinnied before. But the bull stays silent. Does he represent goodness or brutality? Does he even know, himself?

There's a man stretched out; his hand is enormous. It's the hand of a Basque fisherman, or farmer, with earth and sea under his nails. His palm is scored with broken lines.

And with her own great, heavy hand the woman holds her baby's tiny one, which weighs next to nothing.

The painting is hung in the Spanish Pavilion, near the Nazi Germany Pavilion, not far from the Eiffel Tower. Nowadays, a children's merry-go-round whirls on the same spot. Opposite the painting is a portrait of Frederico Garcia Lorca, the poet assassinated by General Franco's supporters in 1936. Next to it is a poem by Paul Éluard, a friend of Picasso, containing the words: 'Death and the vileness of our enemies are the monotonous colour of our night.'

Even the blaze of electric light can't banish the darkness.

When a German officer points his finger at the picture of the massacre and asks Picasso, 'Did you do this?', the painter replies coldly, 'No, you did!'

The bull – focus of everyone's attention – stares at us in silence.

And what of the bird that stands so erect in *Guernica*? It still cries out to us today, telling us something from its shadowy place on the table. But is anyone listening? Does anyone understand?

WOMEN WASHING,
1938

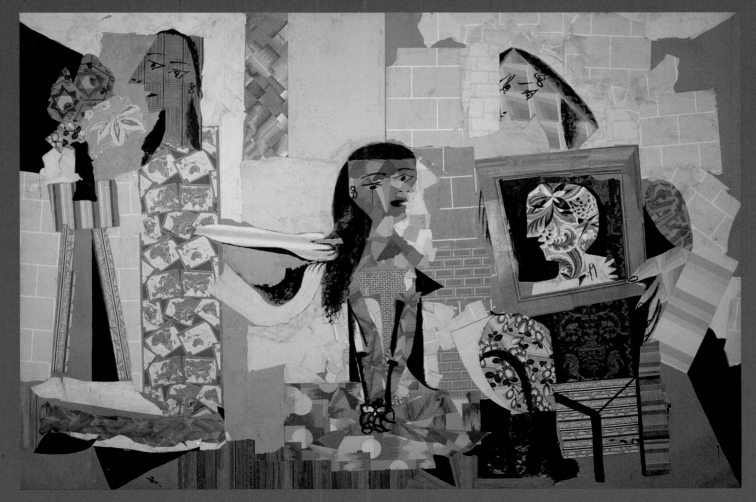

After 35 days and many nights of dedicated work
on *Guernica*, Picasso puts away his pots of black, white and grey.
Colour reappears in his paintings. Life sweeps him along. For his huge collage,
Women washing, Picasso even uses scraps of wallpaper that he'd thought
of incorporating into *Guernica*. In life, death always brings transformation.

The best way to overcome barbarity

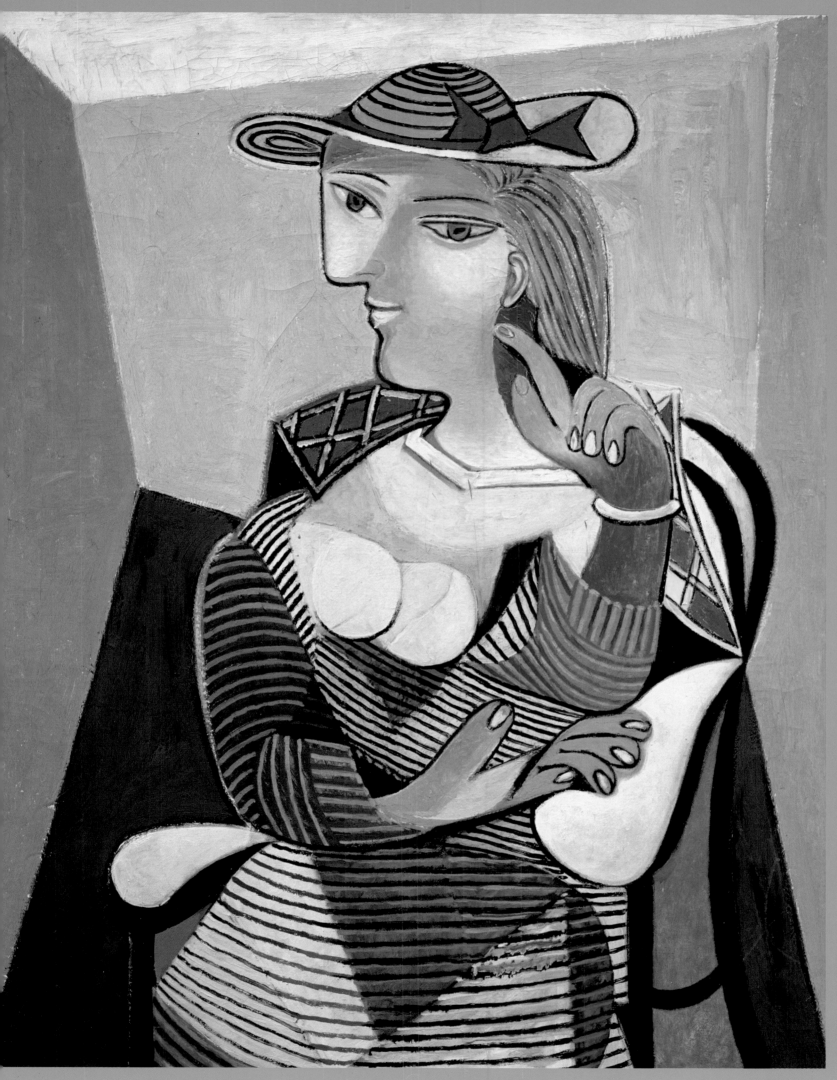

Marie-Thérèse
is Maya's
mother.

*PORTRAIT OF
MARIE-THÉRÈSE,*
1937

must surely be to let the colours of life sing out.

However, 1939 is a year of despair.
In springtime, not long after the
death of Picasso's mother,
the Spanish Republic is no more.

Once again, war has the last word: fighting
breaks out at the end of summer, and,
for the second time, it is a world war.

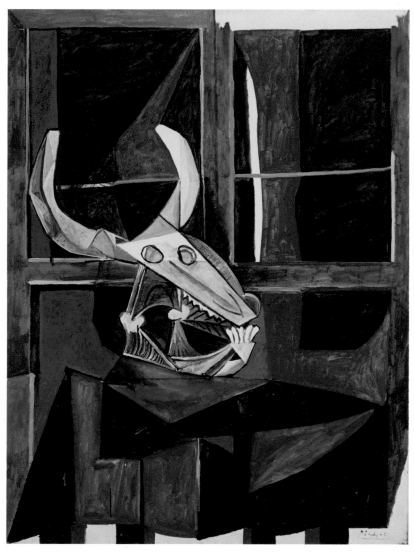

For five long years, darkness reigns.
Nazi Germany invades neighbouring
countries, and carries out the worst
genocide in history, denying more than
six million Jews the right to live.

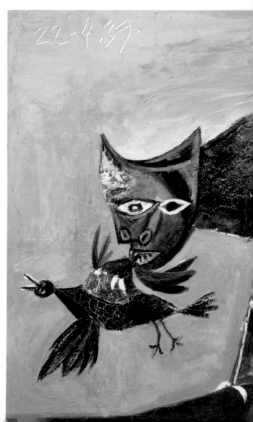

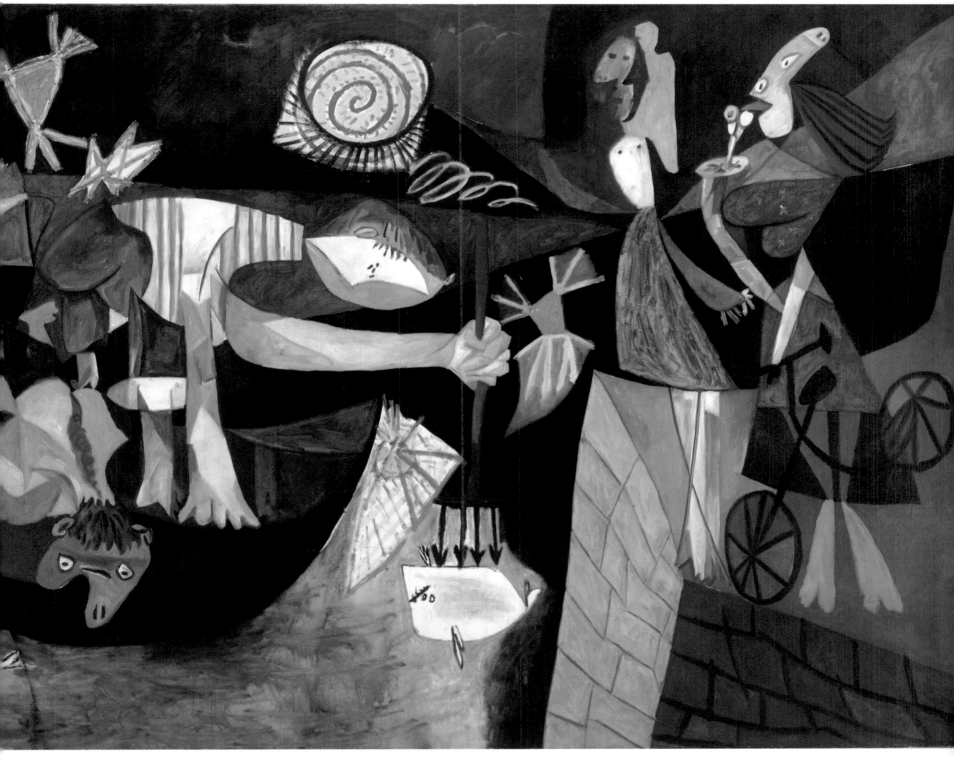

For five long years, Pablo Picasso is forbidden to exhibit.
His work is considered 'degenerate' by the German
authorities occupying France.

But for those five years, Picasso keeps his oil lamp burning.
He paints and paints and paints.

In 1945, when the war is over and France is liberated,
la joie de vivre (the joy of living) bursts out.
Once again, anything seems possible.
Even dancing naked on an island of light.

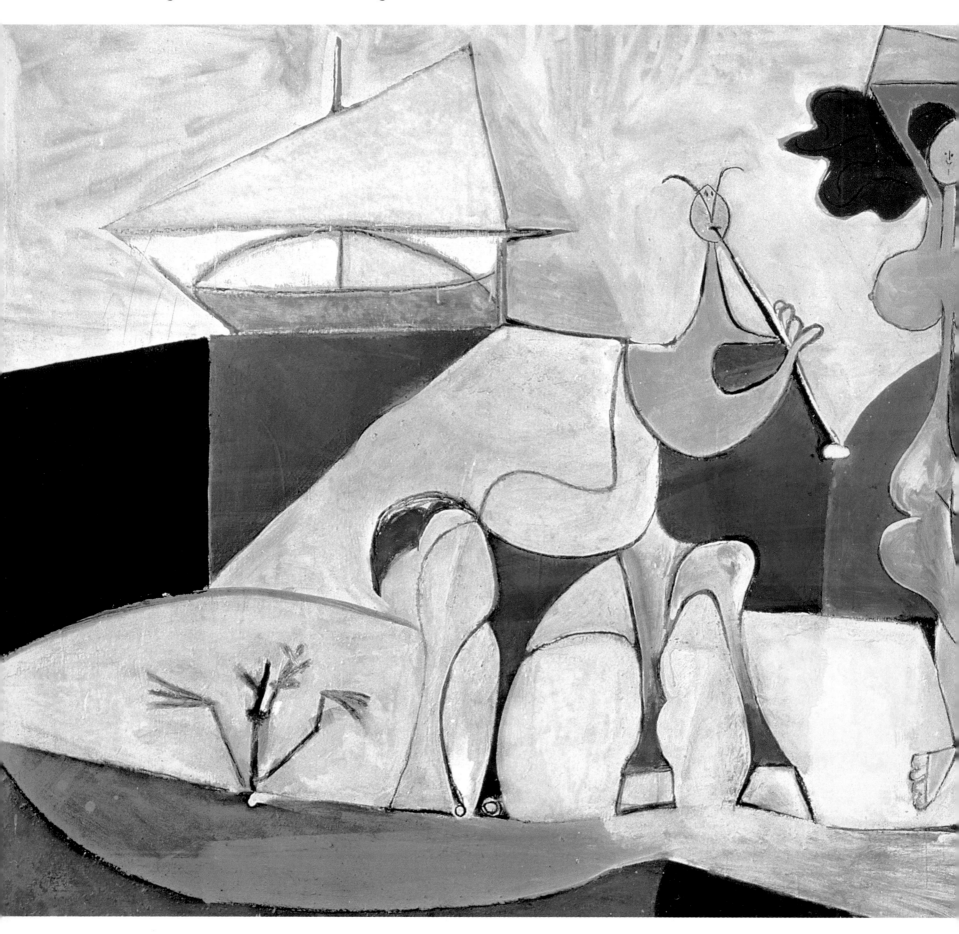

Even being as sensitive as a musician and as strong
as a horse. Even being blue. Or having another child:
a year after Picasso paints this big, cheery canvas,
another son – Claude – is born.

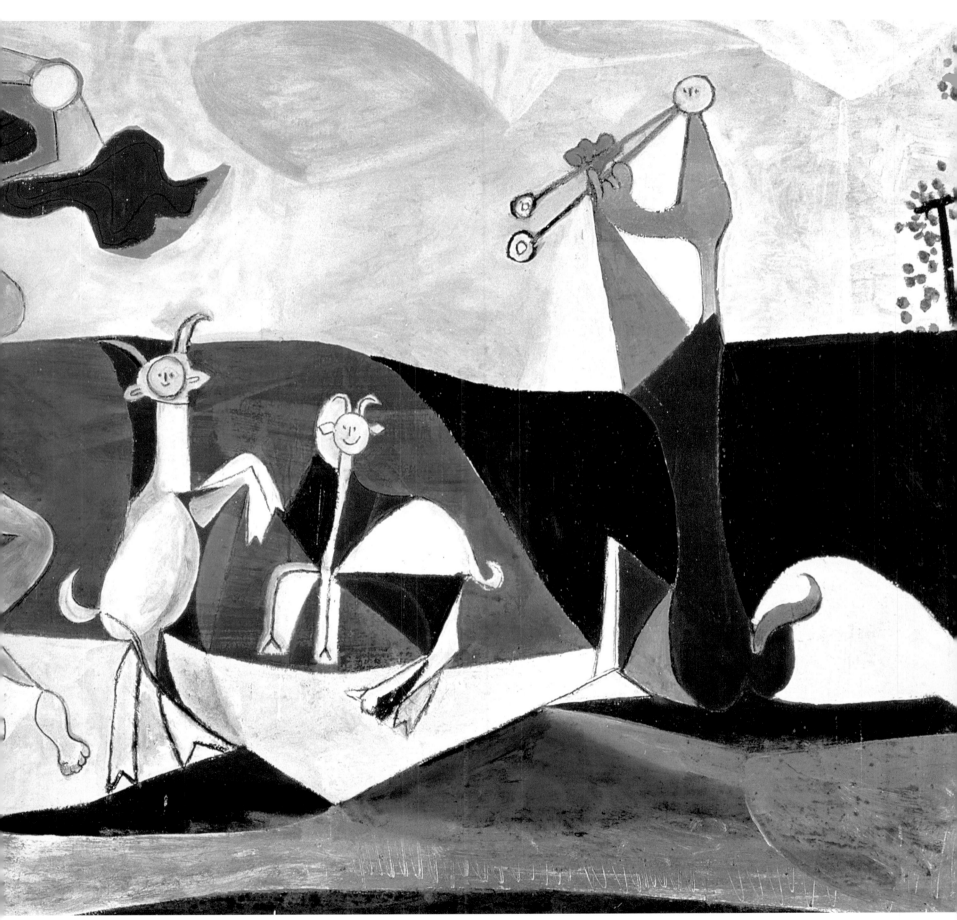

THE JOY OF LIVING, 1946

This century full of wars has been a nightmare. Picasso's friends pester him to create new symbols of peace different from those associated with the famous *Guernica*. They all hope that the more people see the gentle lines of peace, the more they will commit to help it soar freely.

In 1949, Picasso draws a dove for the World Peace Congress held in Paris. At the same time, his fourth child is born. It's a girl, and he calls her Paloma – the Spanish for 'dove'. Picasso draws hundreds of doves, like the ones he helped his father paint so long ago.

One of many doves drawn
by the artist.

DOVE WITH FLOWERS, 1957

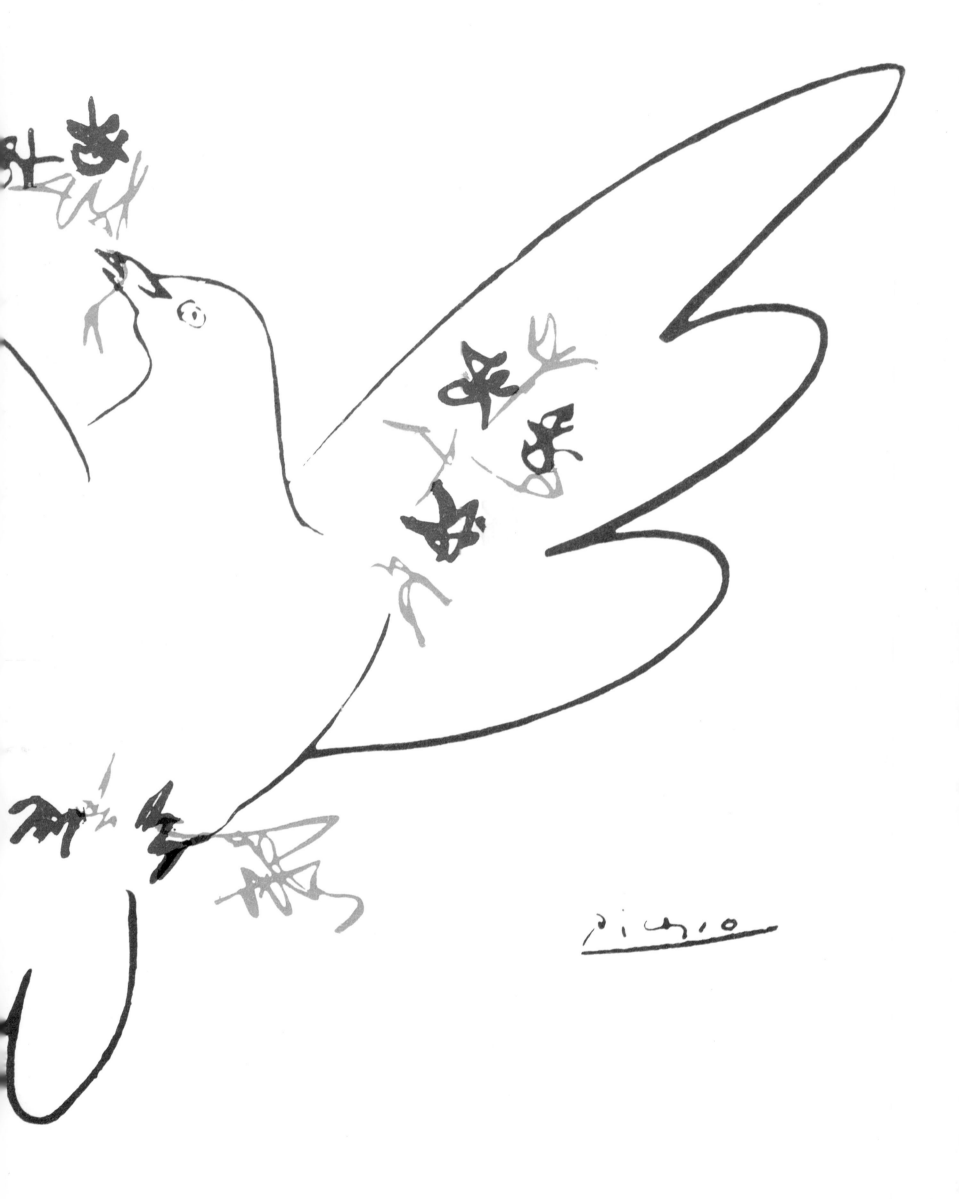

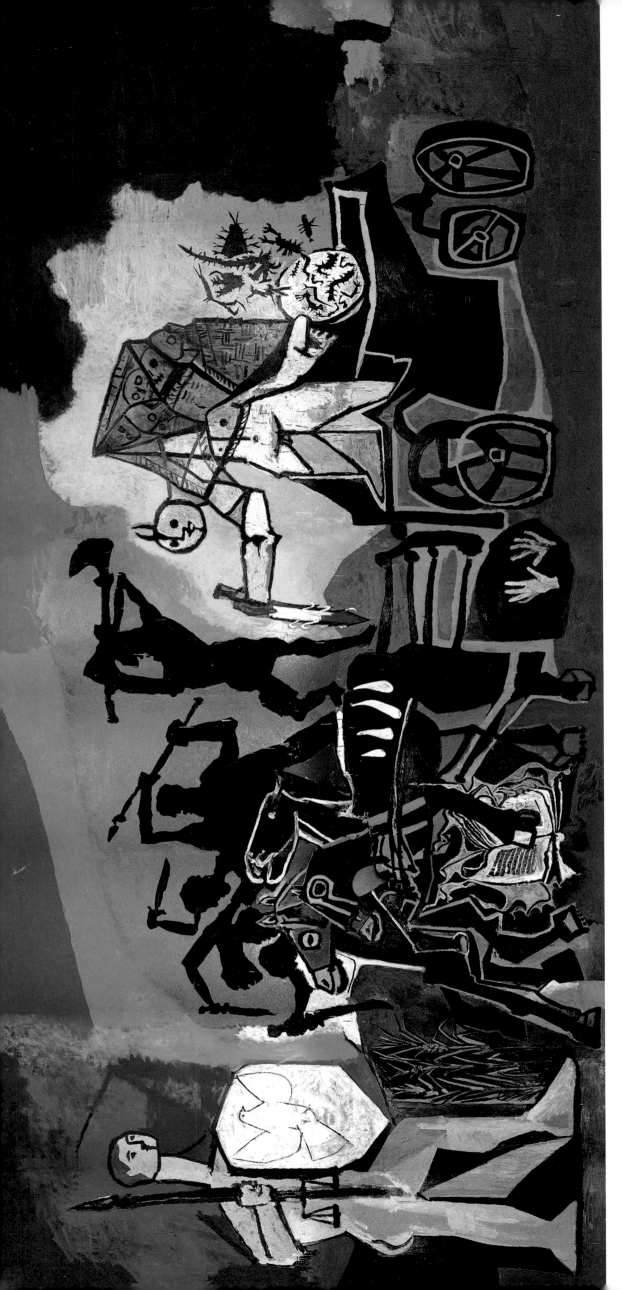

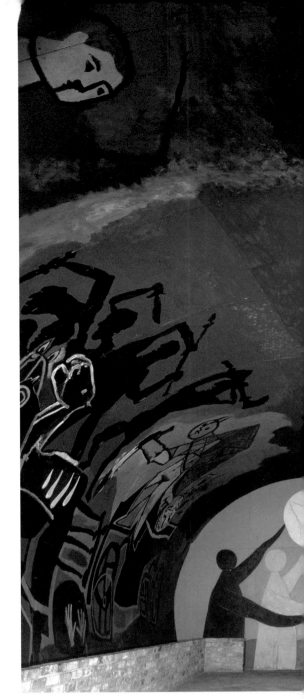

Picasso never gave up his dream

The dream of an Earth
that's lighter than
the shadow of air.

Murals done for the Temple of Peace
in the ancient chapel of Vallauris
(in the French region of Alpes-Maritimes).
WAR AND PEACE, 1952

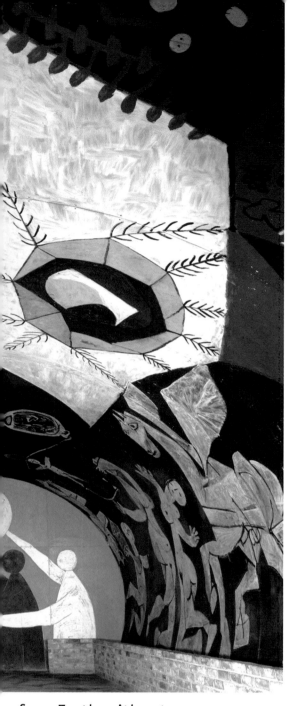

of an Earth without war.

The dream of an Earth
where the only violence
allowed is the struggle
that's needed to create
and never stop creating.

The two huge murals, 10 by 5 metres each,
cover opposite curved walls of the Vallauris
chapel, meeting overhead, on the ceiling.

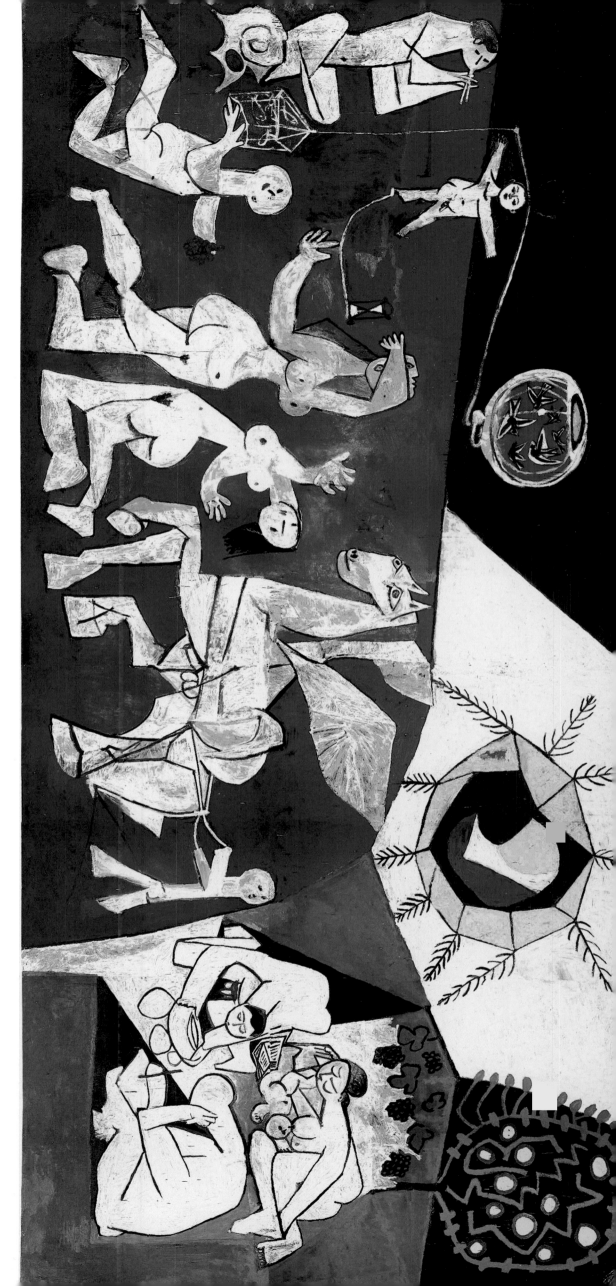

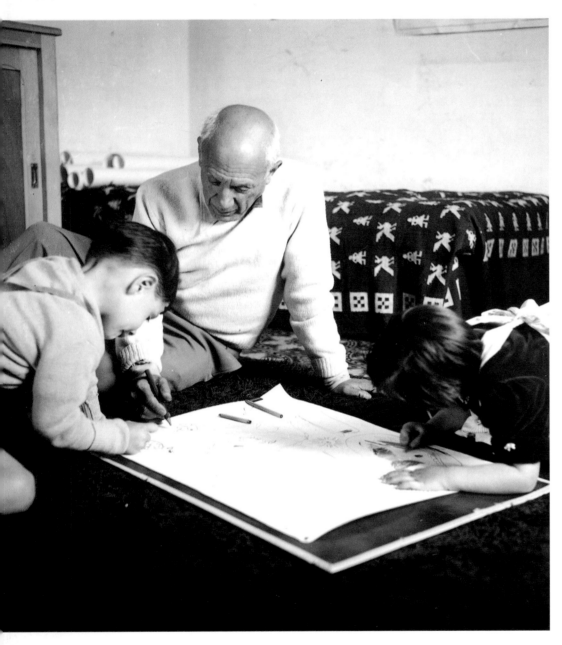

Claude and Paloma drawing
with their father, Pablo Picasso.

To create, the way children create
a big house full of fine horses,
peaceful bulls and lamps that
no one can extinguish.

Using nothing but a pencil
and a piece of paper.

Sometimes even becoming
a great artist whose drawings
speak to men, women
and children.

Claude and Paloma drawing
with their mother.

*CLAUDE DRAWING,
WITH FRANÇOISE AND PALOMA,
1954*

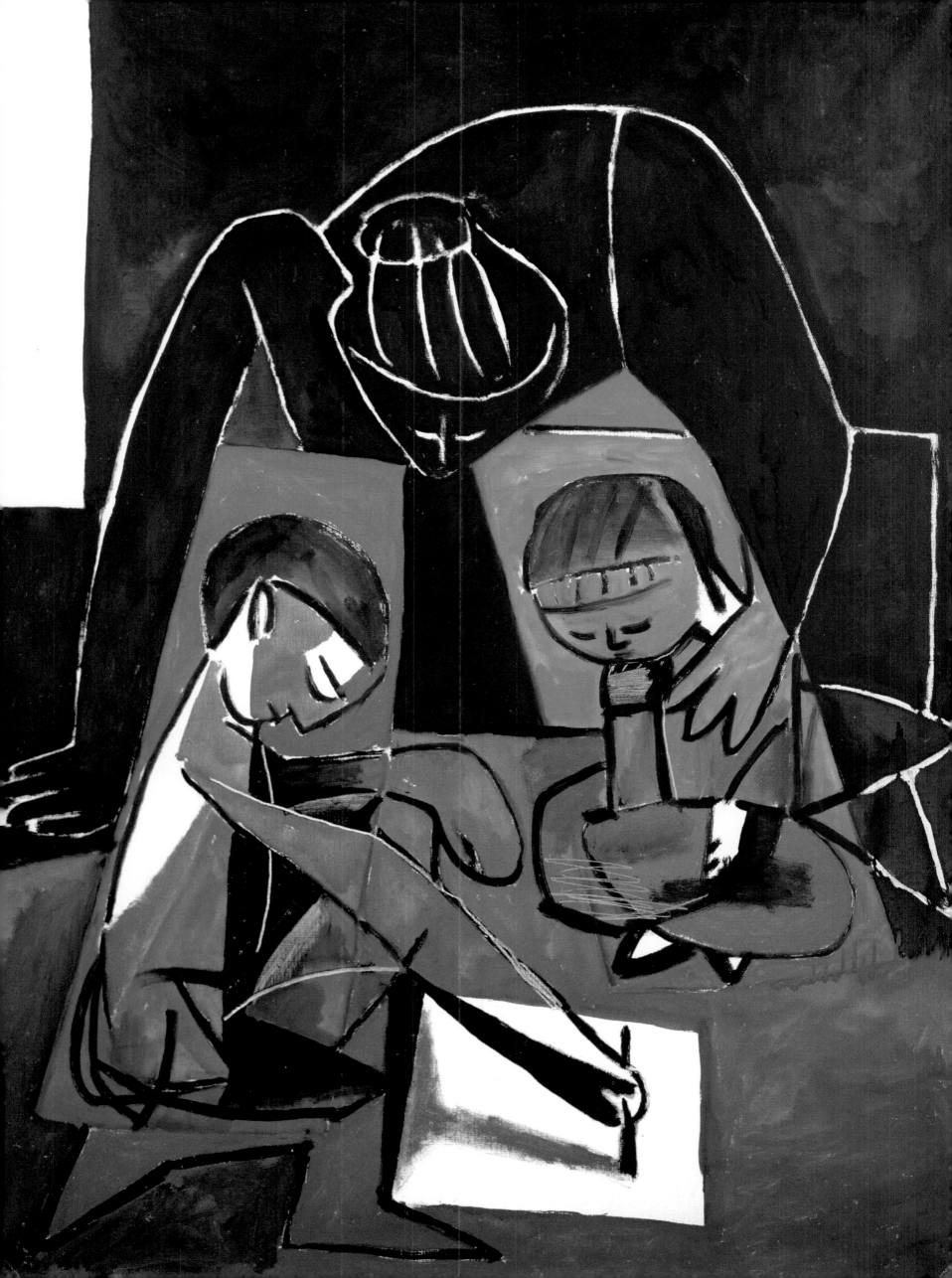

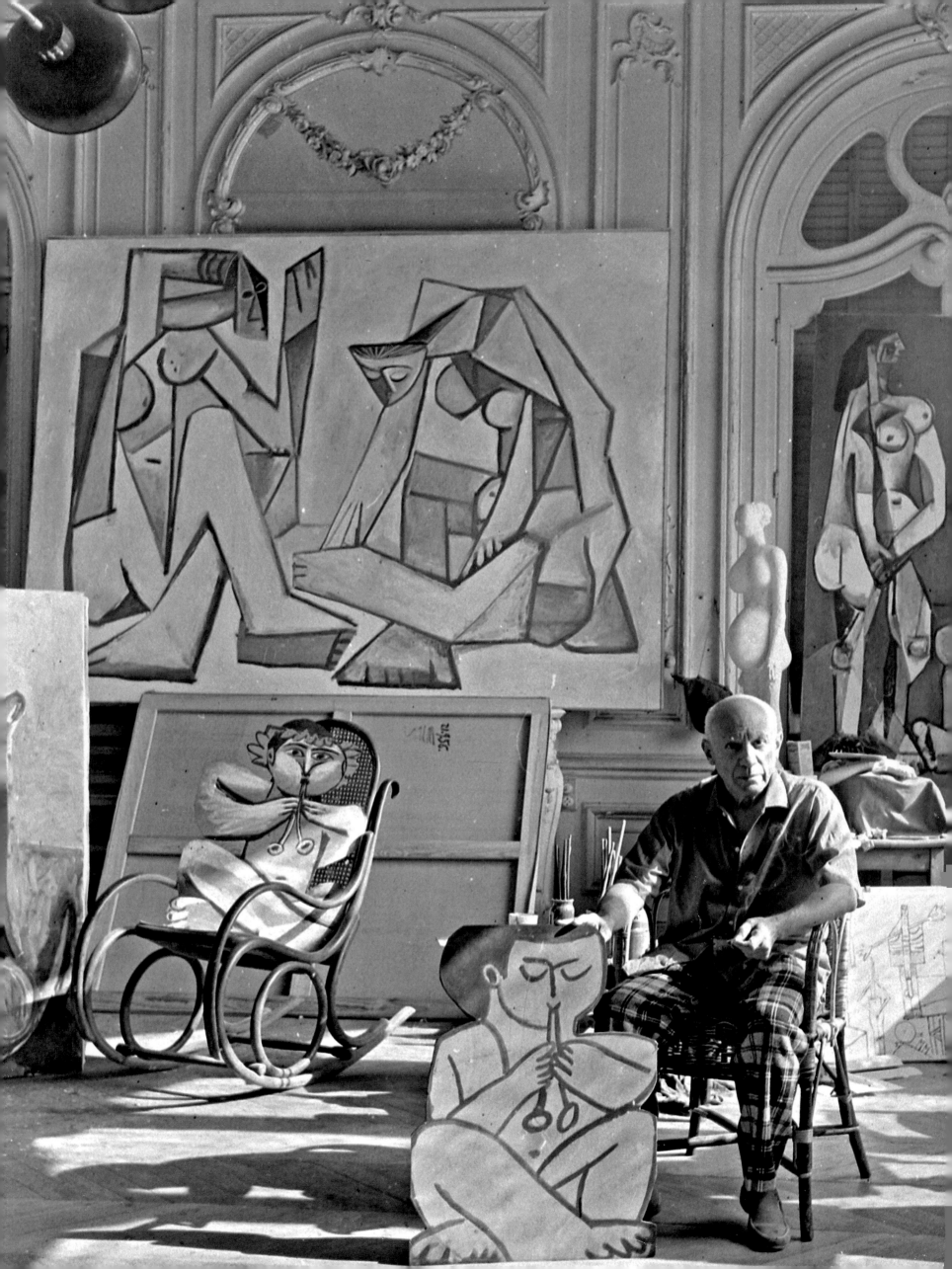

By the end of his life, Picasso will have
painted, drawn, sculpted, cut out,
stuck, modelled or engraved more than
30 000 works: grand old goats, love-sick
lovers drowning in happiness, bulls that
will never know their full selves, women
who want things to be as simple as a
child's soft cheek, market day, fish,
buttocks as round as plates, a sun mask,
children, birds that think they've
achieved nothing, trees used to make
guitars, guitars used as birds' nests,
all the beauty of the world and its
monstrous face as well, delicate jugglers,
blue-painted boats . . .

MASK, 1919

FOOTBALLERS, 1961

Today, we know that the upright bird
from Guernica shouts in our face:
'I have so very many dark, cloudy skies
to paint blue!'

And you – how will you respond when
you see him limping beneath your window?

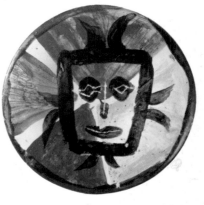

*PLATE, DECORATED WITH
THE FACE OF A FAUN*, 1963

From 1948 onwards, Picasso
settled in the south of France.
He lived in Vallauris, Cannes,
Vauvenargues and finally
Mougins, where he died
on 8 April 1973, aged 91.

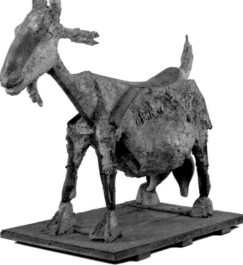

THE GOAT, 1950

In Guernica there is now a peace museum. You can find information, in English, at:
www.peacemuseumguernica.org/en/initiate/homeeng.php, including the link to the Paths of Memory project
www.peacemuseumguernica.org/en/documentation/pathsdocu.html. There are several Picasso museums; the most useful
websites are www.museupicasso.bcn.es/en/ and www.museopicassomalaga.org/

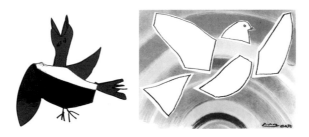

First published in France as *Et Picasso peint Guernica* © Rue du Monde, 2007
© Picasso's heirs 2007, for Pablo Picasso's works

This English-language edition first published in 2010

Copyright © English text, Allen & Unwin 2010

Allen & Unwin 83 Alexander St Crows Nest NSW 2065 Australia
Phone: (61 2) 8425 0100 Fax: (61 2) 9906 2218
Email: info@allenandunwin.com Web: www.allenandunwin.com

National Library of Australia
Cataloguing-in-Publication entry:
Serres, Alain.
Picasso paints Guernica / Alain Serres; translated by Rosalind Price.
ISBN: 9781741759945 (hbk.)
Translation of: Et Picasso peint Guernica.
Picasso, Pablo, 1881–1973. Guernica – Juvenile literature. Guernica (Spain) in art – Juvenile literature.
Spain – History – Civil War, 1936–1939 – Art and the war – Juvenile literature. Price, Rosalind, 1952– .
759.4

Cover and text design by Alain Serres
Printed in November 2009 for Imago at Vivar Printing Sdn Bhd, Rawang Integrated Industrial Park, off Jalan Batu Arang, Rawang,
Selangor Darul Ehsan, Malaysia 48000

1 3 5 7 9 10 8 6 4 2

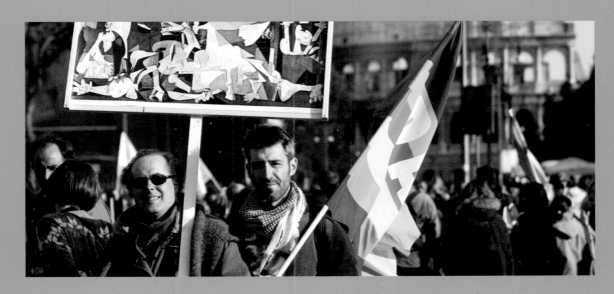

In the streets of Rome (Italy)

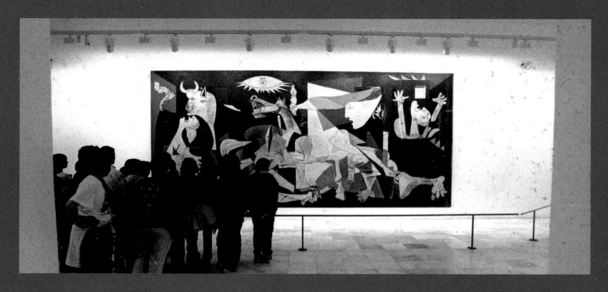

The original, on a wall of the Reina Sofía National Art Museum, in Madrid (Spain)